# The DC Comics Guide to

# PENCILLING

# Comics

Introduction by Dick Giordano

The DC Co

PEN

KLAUS JANSON

mics Guide to

CILLING

Comics

WATSON-GUPTILL PUBLICATIONS/NEW YORK

For Watson-Guptill Publications:
Senior Acquisitions Editor: Candace Raney
Associate Editor: Sarah Fass
Production Manager: Hector Campbell
Cover and Interior Design: Kapo Ng

For DC Comics:
Senior Editor: Steve Korté
Associate Editor: Jaye Gardner
Managing Editor: Trent Duffy

First published in 2002 by Watson-Guptill Publications,
an imprint of the Crown Publishing Group,
a division of Random House, Inc., New York
www.crownpublishing.com
www.watsonguptill.com

**Library of Congress Cataloging-in-Publication Data**

Janson, Klaus.
        The DC comics guide to pencilling comics / Klaus Janson ; introduction by Dick Giordano.
            p. cm.
Includes Index.
        ISBN 0-8230-1028-7
    1. Comic books, strips, etc.—Technique. 2. Cartooning—Technique.
I. Title.
NC1764 .J36 2001
741.5—dc21                                                              2001004381

This book was set in *Times New Roman*.

Printed in China • First printing, 2002 • 7 8 9 / 10

Dedicated to my mother,
who teaches by example.

# CONTENTS

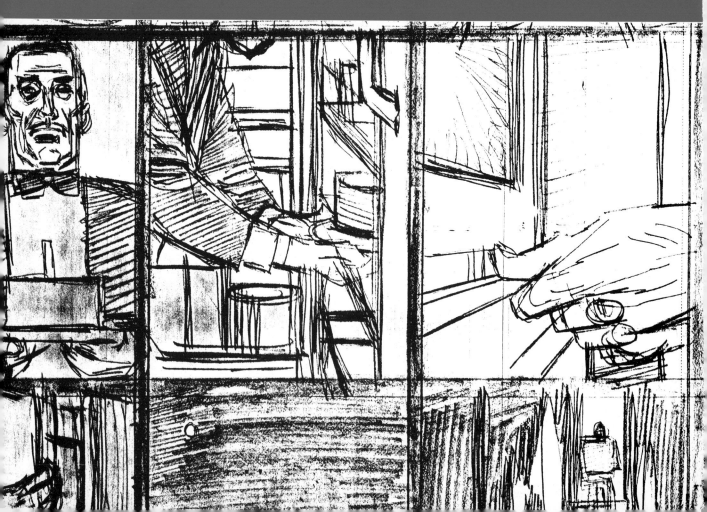

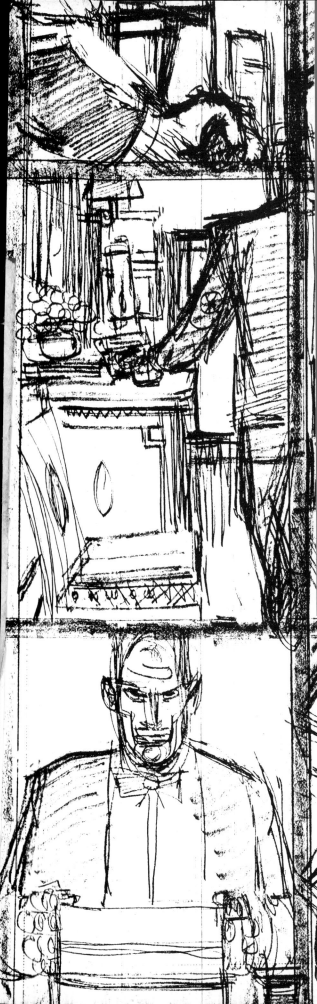

# INTRODUCTION

I first became aware of Klaus Janson while I was the editor at Charlton Comics in Derby, Connecticut, and Klaus was a young comics fan and prolific letter-writer living in Bridgeport, Connecticut, who directed his comments to the letters pages that appeared in our comics. As editor I read all letters and replied to the best ones in the columns. I cannot now recall how many of Klaus's letters saw print, but I do know that I began to look forward to reading his letters each month. They were intelligent, sensitive, and well-informed responses to the work we were publishing at Charlton at that time. After reading a particular emotional letter that he'd written (not about comics but a sad real-world event), I was moved to invite him to Derby to show him a bit of the publishing world and maybe chat a bit.

So we met . . . and became friends. That friendship has endured for more than three decades, despite our separate activities rarely placing us in the same place at the same time. When we do get together, we have that capacity to pick up where we left off that is common between friends.

Our bond? A mutual respect for each other as individuals and as fellow professionals, a mutual love of the comics art form, and a mutual desire to better the form and derive greater satisfaction from practicing it.

I believe that this book is an extension of Klaus's love of the art form of comics—a method of giving something back and sharing with others the knowledge that he has acquired through decades of intense study and hard work. It is written in straightforward, clear, readily understandable, and informative text. The numerous illustrations illuminate and highlight the key portions of each chapter. It was a monumental task to present all this information in such an easily digestible form that is intended for both the individual preparing for a career in comics and the individual loathe to give up amateur status but wishing to take a hobby to another level. Additionally, although the information is specifically slanted to the budding comics artist, it also serves a function in instructing those interested in pursuing careers in illustration or advertising art. Drawing is, after all, drawing.

So, my friend, without further ado, read the book you hold in your hands. It is written by a veteran professional who has risen to the top of his field. Read it, enjoy it, and, most of all, learn from it. The more focused you are, the more you will learn. Remember, there is no fast track to becoming a good artist. Becoming tops at what you do is almost always a triumph of perspiration over inspiration.

It may be a slow trip . . . but since the trip is half the fun, have a good trip.

Dick Giordano

From *Gordon of Gotham* #1 (June 1998). Script by
Dennis O'Neil and art by Dick Giordano and Klaus Janson.

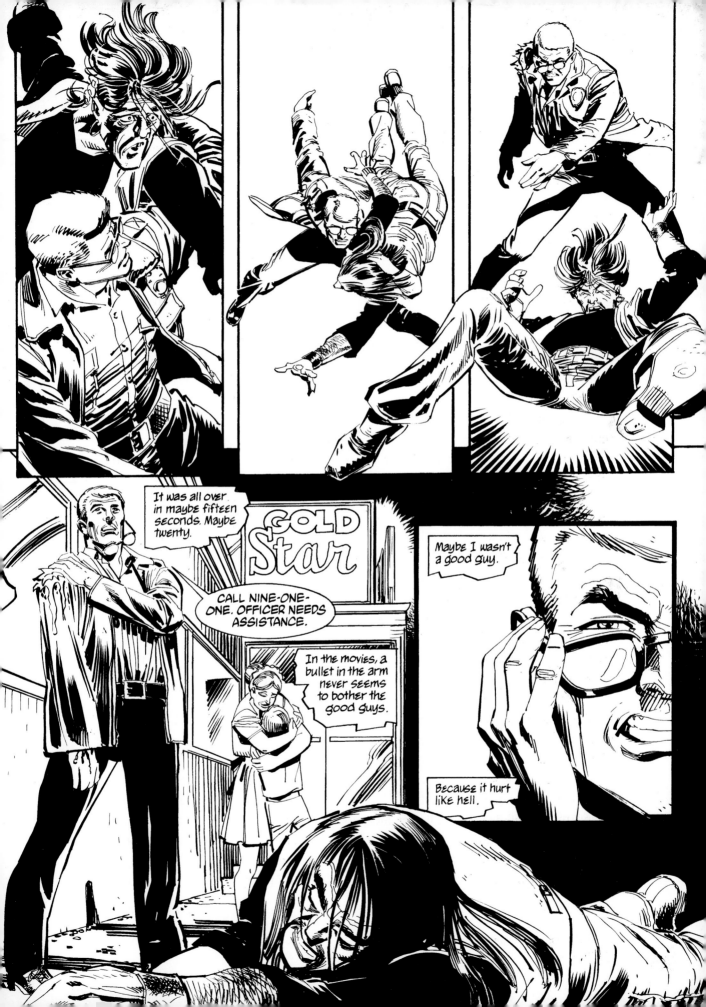

# PART

# ONE

DRAWING

So you think you want to be a comic book artist? You've been reading comics for years and you want to draw your own stories? Congratulations! You've just chosen one of the most difficult art forms available.

Have you ever looked carefully at the drawings of young children? Although interesting on many other levels, they do not fulfill the requirements needed to be "effective" drawings. They do not include any knowledge of perspective, anatomy, or composition. Kids' drawings have no structure.

Artwork in the first comic books was often crude and uninformed. Yet in those early years, when most artists were struggling with basic drawing skills and the language of storytelling, a number of pioneers stood out. Will Eisner, Jack Kirby, Harvey Kurtzman, Joe Kubert, Milton Caniff, Alex Toth, and others led comics into a more visually exciting era. Why? Because they understood the skills and language of drawing.

Drawing involves more than a pencil and a sheet of paper. It requires study. Understanding the various components and disciplines of effective drawing demands a conscious decision and effort on the part of the artist. These will not develop by wishful thinking. Art is a language. To understand a language is to dedicate yourself to the task with resolve and commitment. The following chapters will give you a glimpse of where to begin.

# ONE
# MATERIALS

When I was starting out in the comics industry in the early '70s, I often heard the saying, "A poor artist blames his tools." For the longest time I thought this meant that a good artist could overcome his or her lack of proper equipment and make good art out of anything. It seemed that a passionate and dedicated artist could make art with a stick and some pudding.

I still agree with this theory in general, but it doesn't hold up when it is applied to comics. Comic books add a dimension to the creative process that neutralizes that idea. The fact that comic books are reproduced on a mass scale requires a less casual approach to the work than using any old thing that's lying in the back of your closet. I'm sure *someone* can make art with a stick and some pudding; it's just not the best approach to use for comics.

The comic book medium requires the artist to work with materials and tools that are designed for the specific task at hand. There is absolutely no reason that any artist should undermine his or her work by using inadequate equipment or preparation. Being a good artist in comics is difficult enough. Give the medium the respect it deserves! Give yourself the chance to succeed by using the proper materials.

You will need paper to draw on and pencils to draw with. Some tracing paper would be very helpful with the rough sketches or layouts that every comic book artist must create. An electric pencil sharpener saves a lot of time. Of course, you'll need an eraser or two to erase mistakes or shape your pencil drawings. Rulers, triangles, and circle and oval templates help make the work much tighter and more precise. And you will find that a light box is very helpful. These materials are probably the minimum that an artist needs to start drawing. Let's look at them more closely.

## Paper

The paper used by comic book artists is usually supplied by the companies that hire them. It can vary in quality quite a bit depending on what paper house the publisher orders from, but it is almost always 2-ply thick. There are two textures: smooth and rough. The smooth paper is called *plate* and has a very flat and even surface. The rough paper has more texture, called "tooth," on its surface. You can definitely feel the difference when you hold the papers in your hand.

Your pencils will also react differently to each paper. I find that in both pencilling and inking, the work varies greatly depending on what

The paper you choose will affect your work. Here, the same 2B pencil was used in both examples. Notice how the texture of the coarse paper is revealed in the second box.

kind of paper I use—not only in terms of my line, which is affected by the texture, but also in terms of my own thinking. Because I'm able to draw in a more delicate and detailed way on smooth paper, I tend to draw smaller. The coarse paper, on the other hand, doesn't take detail as well and forces me to think in larger and simpler shapes. Each artist has his or her own preference when it comes to the thickness and finish of the paper used to draw comics. Experiment by drawing the same thing on a few different papers. You will find that the same drawing can look very different on the various papers you try.

The one thing that all of the kinds of paper supplied by comic book publishers have in common is the measurements and markings found around the edges of each board. These crop marks indicate the space in which the artist should draw. There are often additional markings that divide the page in half or thirds or quarters both horizontally and vertically. These marks allow the penciller to be sure that his or her measurements are accurate.

The pages offer two formats from which the artist can choose. One is the *classic comic book page* with a border of white space between the drawings and the edge of the paper. The second is called a *bleed page* because the artwork bleeds right to the edge of the printed page, leaving no border at all. Each format has its good and bad points. The layout that bleeds has a greater chance of being confusing, especially if there's another bleed page next to it. The reader's attention tends to drift to the next page because there is no border to stop the eye movement. On the other hand, the non-bleed approach is easier to read but harder to execute. I prefer a happy medium between the two. I'll often use the bleed paper but not push the art all the way to the edge of the paper just to maintain a degree of separation between pages. I've found that establishing clear borders makes the pages easier to follow. A mix of bleed and non-bleed panels seems to allow for the greatest amount of artistic flexibility. Too much of any single approach tends to get boring; art needs variety and contrast to keep it lively.

The two formats have drawing areas of different sizes. The classic non-bleed format is 9 inches by 14 inches. That means that the entire 9 x 14-inch area is occupied by art. The artist is not required to draw a border around that space, since the area beyond that measurement is the border. The bleed format is a bit larger because you draw beyond the central 9 x 14-inch measurement. To make the art go all the way to the edge of the printed comic book page, the artist should fill a space measuring 10 inches by 15 inches.

# Pencils

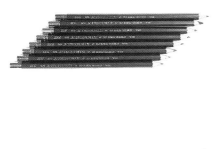

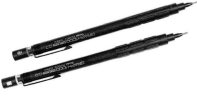

The two options in pencils: the wooden pencil *(top)* or the mechanical *(above)*. Each has unique characteristics. Experiment with as many as you can to find the right pencil and lead for you.

The type of pencil you use will affect your work tremendously. If the same artist pencils and inks the work, pencil type is a personal choice. However, if one artist works on the pencils and a second artist inks the work, the pencils need to be dark enough to be seen by the inker. Outside of this basic requirement, the artist can use any pencil he or she wants.

Look at the side of the pencil you are currently using. You should see a letter, a number, and the name of the company who manufactures it. The letter refers to one of three categories: H is hard lead, B is soft lead, and F is the division between the two. When we refer to a lead as a hard lead, it is literally that: physically hard. The hardest leads can dig into the paper, creating indentations that can make inking or erasing difficult. The softer leads seem to glide effortlessly on top of the paper, without cutting into it. There does not have to be a correlation between hard and dark or soft and light. The softest pencils are often the darkest. The basis for your decision will be, in large part, simply personal taste. You should always work with the materials that provide the best-looking job and make you the most comfortable.

The number on a pencil refers to the darkness of the lead. So, since the letter refers to how hard or soft the lead is, a 6H pencil is very hard and very, very light. No matter how much you press down, the pencil line will never be dark. Be aware of the fact that the further you go into the B section, the harder it is to ink and erase. B pencils have varying amounts of clay in them. The clay forms a barrier between the paper and the ink and prevents the ink from being absorbed by the paper. The inker might have to reink some of the page because the ink itself is lifted off the paper along with the pencil when you try to erase the page.

In my own work, I might use a 2H to get some of the rough shapes down on paper and then use an H or an HB pencil to finish the drawing. If I pencil for myself, I will use a softer lead, because it allows me to draw a more graceful, fluid line. If someone else inks my pencils, I will use a harder lead because it smears much less. Once the pencils start to smear, the work may become unclear for the inker.

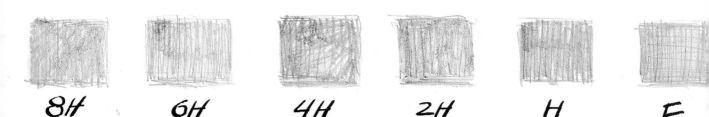

8H        6H        4H        2H        H        F

There is also a special blue pencil that many professionals use for the underdrawing. Unlike regular gray lead, which must be erased from the page before it's sent to the printers so that it doesn't show up in the printed book, the blue lead will not reproduce, so it doesn't have to be erased. The blue pencil is useful for the early work of defining borders and laying in the basic positioning of shapes on the page before any pencilling begins. It allows the penciller to lay out a page without the confusing layers of the various pencil densities.

You'll want to keep all your pencils sharp in order to render the smaller figures, faces, and details of your drawings. Investing in an electric pencil sharpener is a worthwhile idea; I almost doubled my work output when I bought one! It saves a lot of time! Along the same lines, don't ignore mechanical pencils. They come in all the same varieties of darkness and softness as wooden pencils but are consistently sharp and ready to go. You should experiment with all of the different pencil possibilities. What you should use often really just comes down to what you feel most comfortable using. When you get to the point where you have discovered what your favorite materials are, you will be able to do your best work.

## Erasers

There are erasers on the market for many different tasks: picking up rubber cement, erasing lead, cleaning film, etc. My basic rule is: Get the eraser that's right for your job. Also, don't think that the simple eraser is used just to erase mistakes. I always cut a sliver of an eraser off and use it in the process of drawing. Sometimes I'm searching for a boundary or a form and I'll have laid down too many lines to see the shape anymore. I'll take the sharp end of the little eraser I cut away and feel my way around the shape with it, peeling away layers of gray until I get back to where I want the drawing to be. This is called *scumbling*. Drawing with the eraser is a handy technique to put into practice.

Erasers

The various lead weights used on smooth paper. The lighter leads don't smear but can be difficult to see. The darker weights are very discernible but can smear quite a bit.

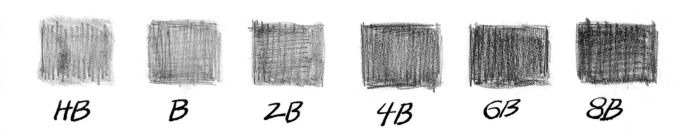

HB    B    2B    4B    6B    8B

# Rulers and Templates

A ruler is a total necessity. Ever try drawing a straight line without one, or ruling borders? Get an 18-inch ruler if you can. It's big enough to work in the 10 x 15-inch space of a comic page and allows you to do any line in one stroke. The larger ruler is also helpful when the vanishing point is off the page (more on that in Chapter 6, "Perspective").

But the ruler is only beneficial when you need a straight edge to render a straight line. What about curves and circles? For that contingency we have templates, French curves, and flexi-curves.

*Templates* are sheets of plastic with shapes punched out of them. They come in a variety of sizes, and bigger art supply stores usually carry many different shapes. I usually just buy the ones with circles and ovals in them because the other forms, like squares or rectangles, can be drawn better using a ruler. Nothing beats a template, though, for giving a curved shape nice, smooth edges. Try drawing an oval freehand, and then draw one using a template. The first one will be shaky and inaccurate. The one drawn with a template will be smooth and precise.

A trip to your local art supply store can be quite an adventure. Go to the biggest and most reputable one in your area. Walk up and down the aisles and look at everything. Hold stuff in your hands and examine it. Does it feel comfortable to you? Ask questions. Above all, experiment! Don't be afraid to try new materials, new approaches. If you do not have a large selection of supplies in your town, get a catalogue or search on-line. You can order anything using either method, and should have no trouble getting the basic materials you need to start your career.

Straight-edge ruler

French curves

Flexi-curve

Oval template

Triangles

# TWO
# SHAPES

Probably the single most important insight into the creation of any work of visual art is the recognition that there is always some underlying structure that organizes the different elements into an understandable message. When non-artists look at a movie, painting, or comic book, they examine what is most obvious—the surface. We've all heard our friends make comments like "Cool special effects!" or "Look at that crooked smile," or "Awesome costume!" But what they see is, for the artist, the end of a very long and complicated series of choices. They do not see the most enjoyable part of creating—the process.

Let me share with you the foundation of the creative act: Everything starts from a general concept and moves to a very specific one. We all work from big to small. No artist I know sits down and starts with the finished page; everyone starts with a layout, a sketch, or even just a thought. If someone dumped all the materials you needed to build a house on your front lawn and told you to build one,

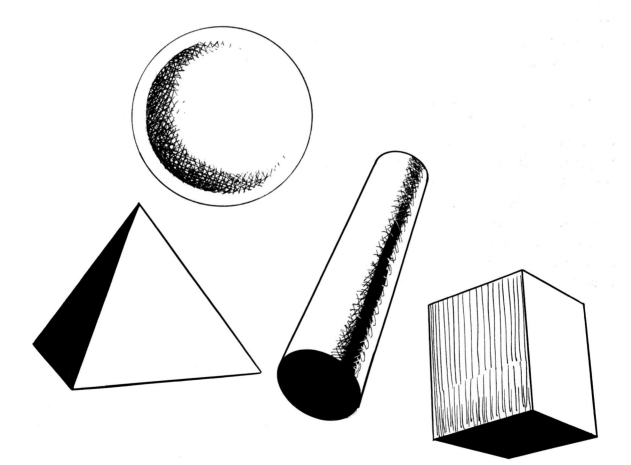

The basic shapes rendered in such a way as to approximate three-dimensional reality.

you probably couldn't. What would be missing is the knowledge of the process, the sequence of events that leads to a strong and functioning house. In the case of a building, we would start with the foundation and build up. In comics, the artist also starts with a foundation. It's called a shape.

These are the basic shapes every artist needs to know: a *cube*, a *cylinder*, a *sphere*, and a *pyramid*. Notice I did not say circle, square, or triangle. Can you guess why? The forms were chosen because of their three-dimensionality. They all have height, width, and depth. The ability to create three dimensions on a two-dimensional piece of paper goes to the heart of a problem artists have been wrestling with since the beginning of time.

The storyteller has the responsibility to recreate the three physical dimensions we experience in real life. The illusion the artist creates helps the reader to believe in the story. It's essential to create an environment that readers can accept; it keeps them focused on the narrative, which otherwise might get lost in the confusion of bad art. Remember that paper only has two dimensions (height and width, but no depth). The best drawings are those that rise above the limitations of working in a two-dimensional medium, and create the illusion of the third dimension: depth.

Without a context, a shape only refers back to itself; it relates to nothing. Other than the shape itself, no further information is available.

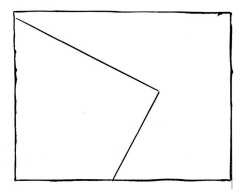

Once the border supplies a context, another shape is created. This area is called *negative space.* Even though only one shape is drawn, two shapes are actually created. However, very little information can be discerned about the original shape.

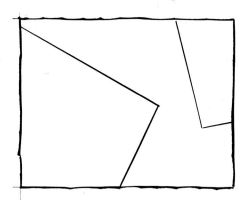

Introducing another shape into the panel only adds one piece of information: the two forms are at an angle to each other. Size, position, and depth still cannot be ascertained.

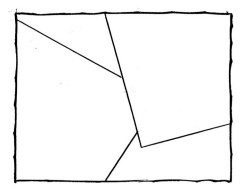

As soon as one shape overlaps another, we see the first hint of depth. Though we don't know the size of the objects or the distance between them, the illusion of three-dimensionality has been created.

Shapes have no meaning, however, without a context—that is, if they are not attached or connected to anything. It's when you put a shape in a frame and start to organize the spatial relationships that you can start to describe some of its characteristics. Once we have some way of "locating" it (using the panel borders as a reference) we are able to tell something about that shape.

Once we have defined the existence of one shape in the context of a panel, we have automatically created another shape: the space that surrounds the first shape. This is called *negative space*. This term is just a complex way of indicating that the introduction of a shape into a panel creates another space that affects the first shape. The two spaces are in a primary visual and compositional relationship.

If we draw another shape into the negative space, the relationship between positive and negative space changes. Now, the primary connection is between the two intentional forms within the panel. The negative space doesn't seem as strong, and it falls into a secondary relationship with the other shapes. The introduction of a second shape gives the reader the first piece of information: the shapes are at an

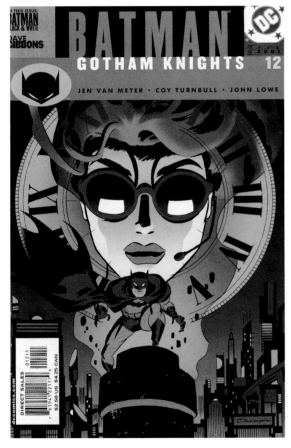

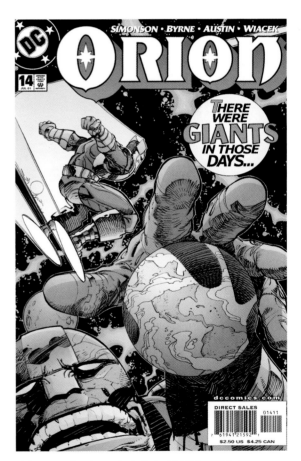

Darwyn Cooke uses the circle as a design element on this cover for *Batman Gotham Knights* #12 (February 2001). Notice how in this and the *Orion* cover *(right)* the circular design is broken by a foreground element. In this case, Batman and the chimney create the illusion of depth by being placed in front of the circular design.

This cover for *Orion* #14 (July 2001) by Walt Simonson very effectively uses shapes to tell a story. It consists of a series of circles (most prominently, the Earth) and one diagonal. The arc of the fingertips also forms a circle. The head in the lower left corner is part of a circle that bleeds off the page. Notice another circle underneath the thumb and another one that contains the cover copy. The diagonal of Orion enters the compositional circle of the fingertips. Notice how the figure deliberately overlaps the thumb; that overlap gives the entire scene a great deal of depth.

angle to each other. We can see if they are positioned at an angle or are parallel to the panel borders. Working at this basic level allows the artist to make the important decisions that will impact the art right up to the finish.

We can gather a certain amount of information from each of the examples on page 18. The information garnered from the first image is fairly minimal. In the second image, we can tell that the shape exists within some other space, but no more than that. Even when a second shape is introduced (in the third image), there is not a great deal of information to be learned. It's only when we place one shape in front of the other—when we use *overlapping shapes* (in the fourth image)—that some basic information can be ascertained. Now we can make an educated guess as to which shape is in the foreground. We also know that one shape is in front of the other. Applying the theory of overlapping shapes in a story helps to communicate critical information to the reader about depth and the illusion of three dimensions.

So we see that shapes influence two very important parts of storytelling: 1) Shapes are the literal foundation of the drawing. They allow the artist to construct a subject or object from its basic structure up to the smallest detail; and 2) Shapes convey information about their own size, shape, and relationship to the spaces or shapes around them.

# THREE
## FACES

Communicating information is always the first priority of a storyteller. I think an artist should focus every aspect of his or her art on furthering that one goal: transferring information from the page to the reader. Some of the information, like time or place, is relatively easy to convey visually. Information of a personal nature, such as someone's character, feelings, or history, is more difficult to represent. If there's any chance of achieving that goal, it will be through the information the artist draws on the faces of the characters.

We begin where we always begin with any drawing: the construction. Construction is the blueprint, the underdrawing, upon which the artist renders the final drawing. Every creative person I know works from the ground up, from the big to small, from the general to the specific. The execution of art is a continual process of change and growth. The drawing is built up by layers. So it makes sense that when we draw faces, or anything else for that matter, we start with the simplest shapes and build up.

Remember these basic tips:
• The eyes should line up with the top of the ears
• The length of the nose should be about the same as the length of the ears
• The hairline should start about a nose-length above the eyes

Obviously, some faces don't follow these rules, so you shouldn't follow them rigidly, either. And in general, when you look closely at a real or realistically depicted head, you will notice that it is not spherical, but rather consists of many curves and angles, known as *planes*. As you move toward a more complex interpretation of the head, it will be necessary to know and understand this part of the construction in order to draw in a more realistic and convincing way.

The fundamental shape that best represents the head is the oval. Let's draw one.

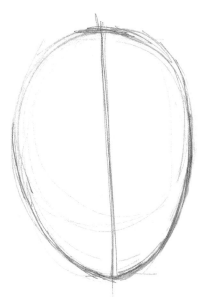

Divide it in half vertically—the nose will appear on this axis.

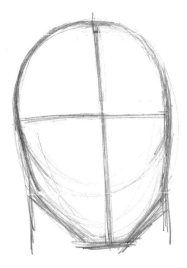

Draw a horizontal line about one-third from the top. That is where the eyes will go.

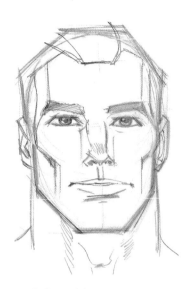

The mouth is positioned halfway between the nose and chin.

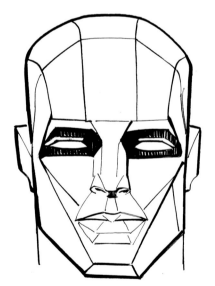

*Left and opposite*: Although the smooth oval begins the facial construction, the face actually consists of many planes and angles.

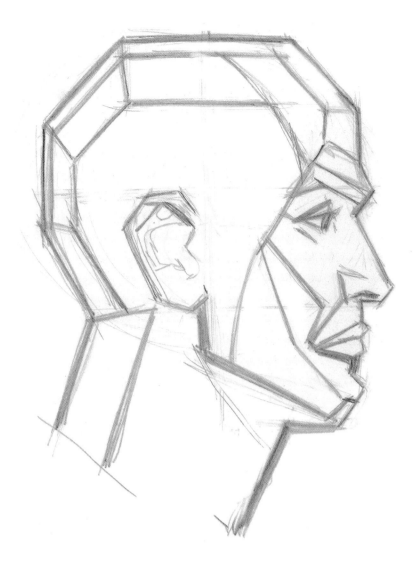

A critical part of being able to draw a believable face is the ability to draw it accurately and consistently no matter what the angle. Heads and faces are almost always the center of attention in a panel—you really have to work hard to shift the focal point away from the face. So the more time and attention the artist can give to a face, the greater the rewards!

Perspective may not be the first thing you think of when you think of heads or faces, but just consider the possibility of drawing a face without using perspective. I wouldn't know how or where to begin! Once you recognize that the head is a three-dimensional object, perspective is the most natural route to choose in its construction. All of the moving and non-moving parts of the head need to be drawn in perspective in the same way that the human figure needs to be drawn in perspective.

When the mouth is open, for instance, the teeth must be aligned in the correct perspective and relationship to the head itself. I've seen a lot of art that could have been saved if the artist knew how to apply the principles of perspective.

In addition to making sure your faces are anatomically correct, you have to devote some attention to another layer of information: *characterization*. It's important to establish visual clues that provide some insight into your characters' individual personalities. In Westerns of the 1940s and

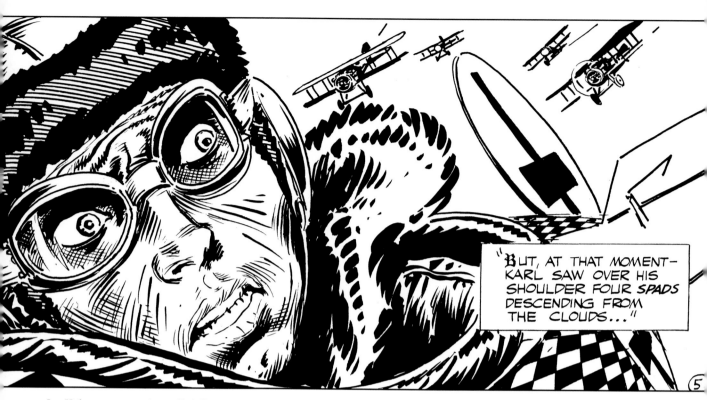

Joe Kubert uses a variety of ink lines to emphasize the shape and volume of the pilot's face. From *Star Spangled War Stories* #141 (October 1968). Script by Robert Kanigher.

An advocate of construction and under-drawing, Gil Kane uses lighting to emphasize the angles and planes of the face to create depth, volume, and weight. Notice the overlapping shape of the lampshade in front of the shadow of the window. Had the black shadow been placed above the shade, the illusion of depth would not have been as strong. From *Action Comics* #546 (August 1983). Script by Marv Wolfman.

Though the head may be tilted at angles unfamiliar to us in everyday life, the laws of perspective must still be followed. Note that facial features still line up with their corresponding counterparts.

The lighting on this face creates a great sense of volume. The side of the head is particularly effective; it seems to recede into the back of the panel. The creation of depth continues in other parts of the panel. In the foreground, the shelf, book bracket, hand, and book create a compositional frame in front of the scene, pushing the smaller figures at left into the middle and background of the panel. From *The Brave and the Bold* #83 (April 1969). Script by Bob Haney and art by Neal Adams.

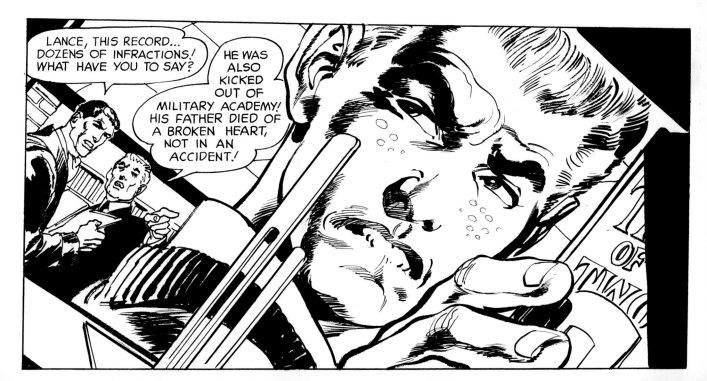

1950s, a consistent visual clue was the color of the hats the characters wore: black hat meant bad guy, white hat meant good guy. The bad guy was unshaven; the hero looked clean and pure. Audiences were able to establish very early on who was on what side by the way the characters looked and dressed.

Clothes and costumes can work very effectively as visual shorthand. More complex characterization, however, takes place on the face and head. In addition to indicating aspects of the personality, the face has the capacity to reveal a character's emotions at a given moment. Nothing could be more clear and exciting than that. The artist needs the face to communicate those feelings to the reader. A white hat on a hero is iconographic. Glasses on a character may indicate a more studious, reserved nature. Pigtails on a girl may be a symbol of her innocence. Don't waste an opportunity to use physical traits to represent character. An artist needs to be creative and imaginative in communicating personal information. A weak chin, big or small ears, long or short hair, and a unibrow all are physical facial traits that may indicate character. Whatever specific look or symbol is chosen, there can be no doubt that the quickest route to the reader's attention is the face.

# Eyes

Of all of the facial components, the most expressive is the eyes. When looking at a drawing of the human figure, the viewer always notices the head and face first. By the same token, when looking at a head shot, most people tend to look at the eyes first.

A while ago, I took part in a panel discussion at a comic book convention with some other storytellers. The audience was throwing some questions at us. A hand shot up and someone asked, "What is the hardest thing to draw?" An artist on the panel responded by saying, "The other eye." He went on to say how difficult it was to match the eyes up.

Later, this made me think that perhaps trying to keep them alike was the real mistake. The more I studied the eye, the more convinced I became that I was on the right track. The only time that we can reasonably attempt or expect to have the eyes match exactly is when the face is looking straight at the camera. If the head starts moving in any direction other than straight on, the eyes will never match. Each eye must respond to the different positions and angles of the face.

A rough approximation of how the eyeball sits in the skull.

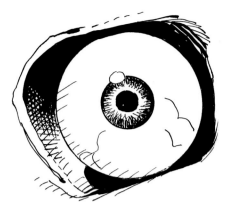

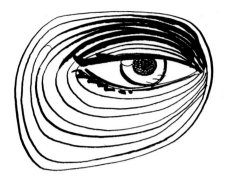

The eye in the socket without skin.

The eye with skin. Now you can see the shape the skin takes around the eyeball and socket.

The eyeball moves within the socket, while the iris—the colored portion of the eye—is locked into position on the eyeball. It cannot move independently of the eyeball. How much of the iris we see depends on the angle of the head. If the head is tilted back or the eyeballs have rolled up into the head, we see only the white part of the eye. The iris is covered.

Gil Kane uses every component of visual storytelling to communicate information to the reader. Here he uses the eyes, the body language, and the compositional opposing angle to reflect the emotional states of the characters. From *Captain Action* #4 (April 1969).

# FOUR
# ANATOMY

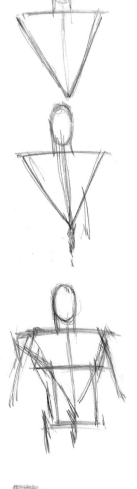

One of the reasons comic art is one of the most difficult of all art forms is the amount of knowledge the artist must possess. A comic book storyteller has responsibilities equivalent to those of an entire movie cast, crew, and production staff rolled into one, and delegation isn't possible. Research, equipment, lighting, costume design, choreography, editing, set design, and directing are all a part of the storyteller's job.

In order to be successful, comic book artists also have to be able to draw the figure credibly, no matter what the pose or angle. That means that they need a solid grasp of human anatomy—a better grasp than they would need for, say, storyboarding or advertising. A *storyboard* is a sketch that serves as a bridge between the script and the finished image. The sketches are often rough and incomplete; a simple shape will sometimes suffice. This early stage of a comic book is not meant to be seen by the public. Advertising anatomy also tends to be uncomplicated, because advertisers and comic book publishers have far different needs. In a comic book, the figures must be used to tell a story—not just to sell the latest hairdryer.

One of the advantages of comic book anatomy is that it allows a wider spectrum of anatomical interpretation than other media or areas of study. Comic artists have the freedom to draw the human body in a variety of styles. The basic proportions of the human body can be exaggerated and distorted in comic book art. There is no single standard as in medical anatomy, for instance, which must be very precise and exact. This is not to suggest that the artist can ignore the study of basic anatomy. The personal interpretation is built on top of realistic anatomy and is not meant to be a replacement for it.

Try to remember that the quest for ideal anatomy comes second to developing the storytelling ability. Storytellers can fulfill the desire to communicate even if their drawing skills are immature. Knowing how to use sequential images to reach the reader can always save crude drawing. A great drawing, no matter how beautiful, is useless unless you know what to do with it.

There are many layers to the study of human anatomy. This chapter deals with two of them: the *structure and design* of the human body; and its *movement and balance*. Knowledge of both areas serves as the foundation for drawing all figures, whether they are dressed as superheroes or wearing street clothes.

On these pages, I have provided a simple example of the various stages of human construction. Remember to always work from general to specific.

# Structure and Design

To start drawing the human form, you will need to build up from the common shapes we mentioned in Chapter 2. As we've learned, the head is built up from an oval shape. There are a few more shapes involved in the construction of the body. In my own approach to anatomical construction, I use the oval, triangle, and rectangle. Traditional construction suggests using an oval or a barrel shape for the chest and torso areas. I prefer to use two shapes in tandem with each other: a triangle and a rectangle. After sketching in the oval for the head, I draw a neck and place a horizontal line below it to indicate where the clavicle and shoulders are. I then draw two lines to form a triangle. This tells me the width of the shoulders and locates the chest, belly button, and pubic line down the front of the figure.

After adding the triangle, I snap in a rectangular shape to approximate the shape of the abdominal area. The bottom of that rectangle should be about where the top of the pelvis will be. I'll use the bones of the arms and legs to tell me the curve or angle of the limbs and build muscle onto them.

For the male, I use a figure that is between 8 and 9 heads high. I think of an 8-head-high body as about 5 feet 10 inches high. Nine heads high is about 6 feet 4 inches. That range between average and heroic is comfortable to me. Obviously, there are bodies that go below or above those estimates. Part of the fun of visual communication is deciding the look of your characters, including their height and weight. In the process of drawing a character, the artist is constantly adjusting the figure. These suggested head lengths are not meant to hinder your creativity or go against your personal judgement. Draw your character first, then use these measurements as a reference point in your final decision-making process.

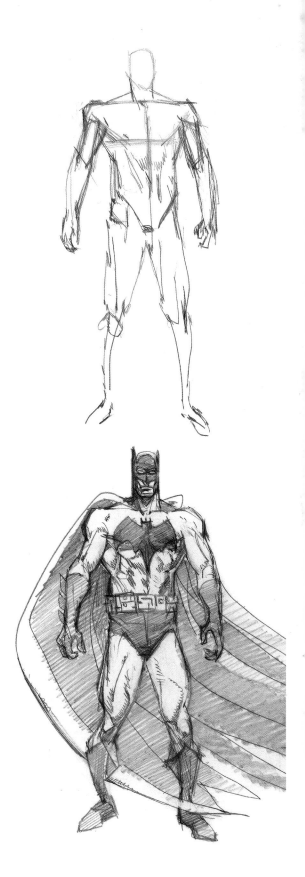

*Right*: This diagram suggests some of the differences between a heroic figure and one that is more realistic. The ideal romantic lead is drawn 9 heads high. The realistic figure is approximately 8 heads high, but is not simply a smaller version of the heroic figure. For example, note that the horizontal lines hit different points in each body.

*Below*: A three-sided view of a 9-head-high woman. At these proportions, this would constitute an anatomically heroic figure. In real life women aren't usually quite that tall. Remember that many of the people you draw will be below or above the 8- or 9-head proportion. Individuality is a key quality for all your characters. Pick the height and body type that best fit the subject.

The body height of a woman has the equivalent proportions. An 8-head-high female is the equivalent of about 5 feet 8 inches. The 9-head-high female translates to about 6 feet 1 inch.

The male and female body share some basic similarities. In general, the muscles of the arms and legs are structured the same in both genders. However, there are some notable differences between male and female anatomies, especially in the pelvic region and the chest area.

The female form has a larger pelvis, which makes for a much rounder mid-section than that of a man. This is clearly visible in the front view. A woman's belly button should also be drawn a bit higher than a man's, and a woman's waist should be smaller than a male waist. The side view offers a glimpse of another difference that actually accounts for the differences we see from the front view: the male pelvis is almost horizontal with the floor, while the female pelvis maintains a much greater angle to the horizontal.

The torso contains a few differences also. Both men and women have pectoral muscles—*pectoralis major*—on the chest. Stripped down to just the muscle of the body, the torsos of both genders look alike. The female however, has breasts that cover the pectorals. Because the chest area of both men and women are divided into two, they are shapes that do not emanate from the body at the same angle.

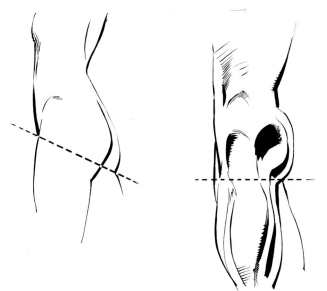

*Right*: One of the biggest differences between male and female anatomy is in the structure of the torso. As we can see here, female *(left)* and male torsos end in different angles above the thigh. In tandem with the higher female waist, this structural difference accounts for much of the physical contrast between the genders.

*Below*: A lot of beginning artists aren't aware that the chest area comes at the camera at an angle in both men and women. Many insist on drawing the nipples parallel and identical, which they are not. Ignoring the angles of the chest affects the rest of the anatomy, ultimately leading to an unconvincing anatomical interpretation.

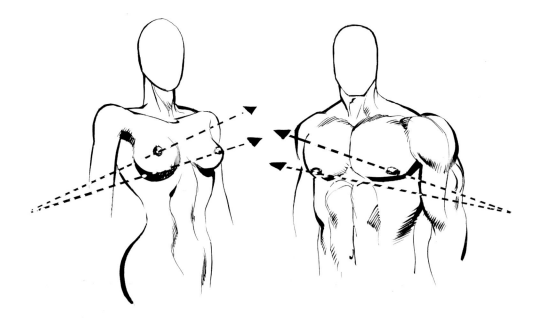

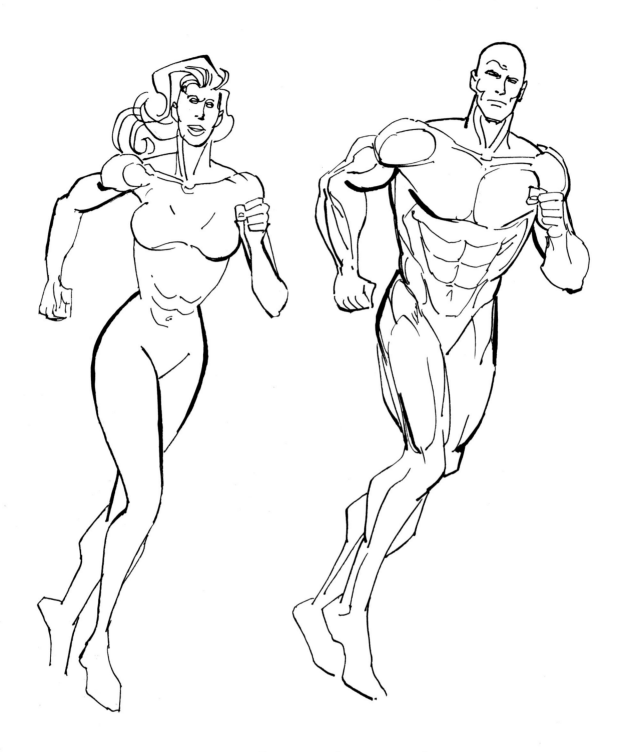

# Head and Neck

The head is attached to the body by the neck. There are a few major landmarks that you need to know to credibly illustrate that construction. The two *sternomastoid* muscles extend down from right behind each ear to the front of the neck, where they meet in the middle. Together, they control the up-and-down movement of the head, while using one at a time enables the head to move from side to side.

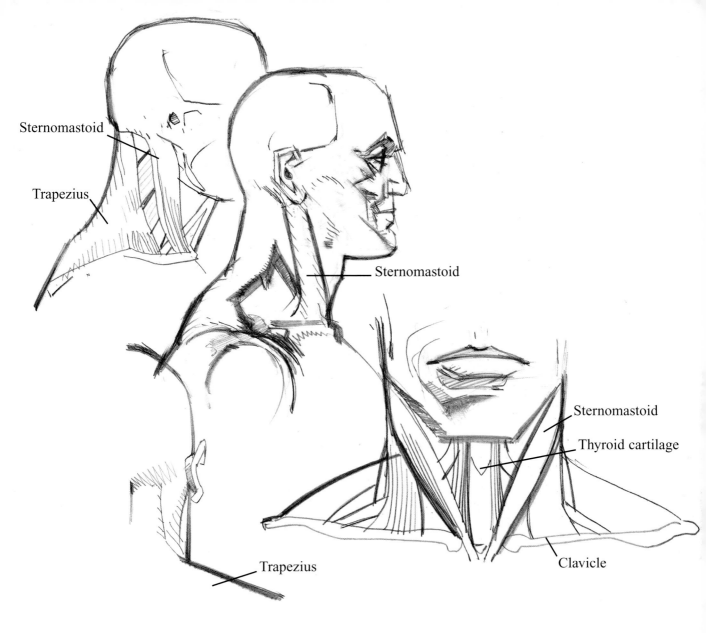

Sternomastoid

Trapezius

Sternomastoid

Sternomastoid

Thyroid cartilage

Trapezius

Clavicle

At the back of the neck are the *trapezius* muscles. They are attached to the bottom of the skull and extend both downward to about halfway down the back and sideways (forming a wing-like shape) to the top of the shoulder bone, where the tips connect. From the side view, it's apparent that the neck has an angled axis thrusting both downward and back.

A big difference between male and female necks is the Adam's apple, technically known as the thyroid cartilage. A common misconception is that women do not have Adam's apples. While this is not true, it is true that the female Adam's apple is small enough to appear nonexistent.

You can clearly observe the man's Adam's apple in this rendering of the male and female neck.

# Torso

The torso is the area between the collarbone and the waist. From the front, it consists of two main parts: the rib cage and the abdomen. Immediately below the collarbone and above the rib cage are the chest muscles. The bottom of the male chest is usually at about the same level as the bottom of the shoulder muscles. When the arms are down at the sides, the male pectorals cover the expanse of the upper rib cage. When the arms move up, however, you'll notice that the part of the chest that remains attached to the rib cage is only from the nipple inward. The sides of the pec muscle flare up with the arms and forms a concave area between it and the lat muscle.

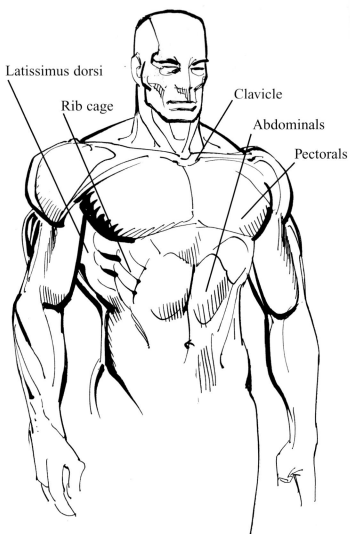

Latissimus dorsi

Rib cage

Clavicle

Abdominals

Pectorals

A few other torso landmarks can be used to guide you to a more correct anatomy. The rib cage starts an inch or two below the clavicle and ends just above the belly button. It forms an upside-down U-shape in the front. Starting behind the bottom of the rib cage and reaching to the pubic area are the abdominal muscles, which should be a bit narrower than the width of the chest between the nipples.

A shot of the male figure with arms lifted. Notice how the edge of the *latissimus dorsi* puffs up, forming a bowl shape between it and the pectoral muscle. A muscle can change shape or size but it is critical to remember that it never detaches from the bone to which it is anchored.

Besides the neck, the abdominal muscle *(rectus abdominis)* has the greatest range of flexibility of any muscle in the body. The abdominals can stretch up and appear flat or compress so that they squeeze on top of each other and appear more rounded. It is an example of how the muscles in the human body can look different depending on the angle, lighting, or muscle tension.

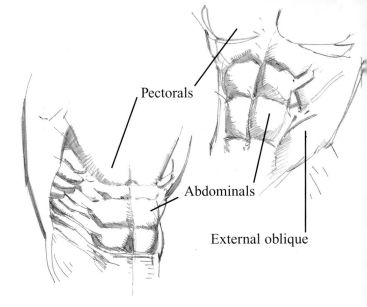

Pectorals

Abdominals

External oblique

# Back

The back of the rib cage holds a huge mass of muscle. We've seen that the trapezius, extending down and out from the back of the skull, forms a small V shape on the upper third of the back. It connects to the top of the shoulders, which are considerably larger when viewed from the back.

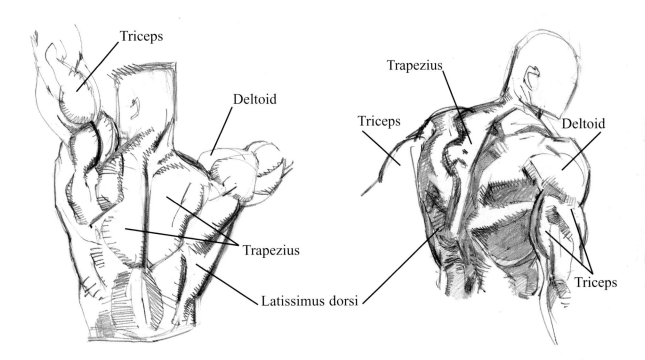

Triceps

Deltoid

Trapezius

Latissimus dorsi

Trapezius

Triceps

Deltoid

Triceps

To the side and below the trapezius lies the *latissimus dorsi,* or the lat. This is the muscle that gives the male torso a tapered or V-shaped look. The lats wrap around the side of the body from the trapezius to the rib cage. In the same way that you might think of the abdominals as snapping into the rib cage, think of the rib cage as snapping into the larger wing shape of the back.

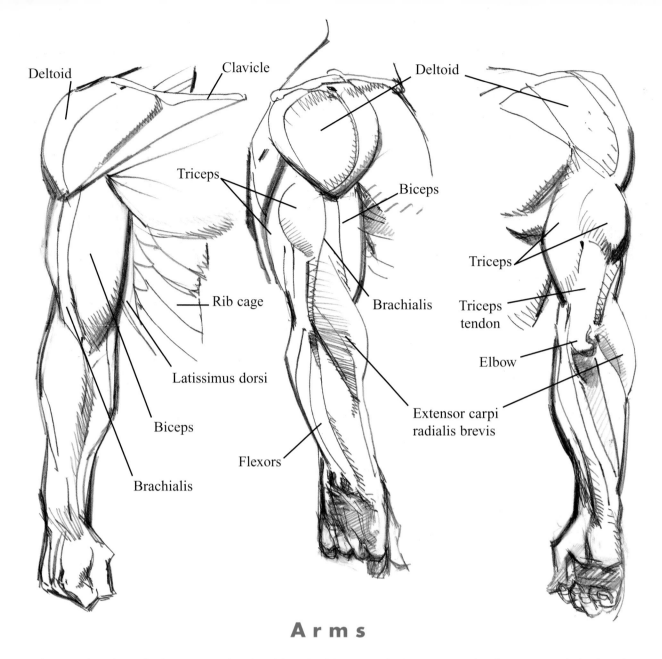

Deltoid

Clavicle

Deltoid

Triceps

Biceps

Rib cage

Triceps

Brachialis

Triceps
tendon

Latissimus dorsi

Elbow

Biceps

Extensor carpi
radialis brevis

Brachialis

Flexors

# A r m s

The arm has four distinct parts: the shoulder, the biceps and triceps area, the forearm, and the hand. The shoulder has three sections: the front, middle, and back. When the arms are at rest, the majority of the shoulder mass is at the front of the body. As the arms are lifted, more of the mass shifts to the back of the figure.

The bottom of the middle part of the shoulder always slips in the space between the biceps and the triceps where it meets the *brachialis*. Some people are under the impression that the biceps is the dominant muscle of the upper arm. It does have a reputation for being the glamour muscle, but it's the triceps that is the larger of the two. From the front view, only a sliver of the triceps can be seen. But from the side and back, you can see what an important role the triceps muscle has in the appearance of the arm. The biceps is completely obscured by the triceps from the back view and seems to shrink in comparison.

From the side, you can see that the triceps and biceps are separated by the brachialis. In between the brachialis and the triceps lies the top of the forearm. This muscle, called the *flexor carpi radialis,* starts a bit more than halfway down the biceps and continues to the inside of the wrist.

The forearm is more complicated than the upper arm. It is composed of fifteen muscles, whereas the upper arm has six and the shoulder only three. There is a railway of *flexor tendons* that travel down the middle of the front and back of the forearm, pass through the wrist cable, and proceed to the tips of the fingers, where they control the movement of the hand. Move the fingers of one hand while your other hand is resting on your forearm. You should be able to feel the flexors working as they move the fingers.

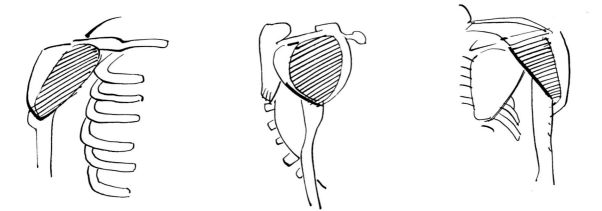

Three separate parts of the shoulder grouping: the front, middle, and back.

When the arms are at rest, most of the deltoid is seen from the front, but when the arms are lifted, the shoulder masses shift mostly to the back of the body.

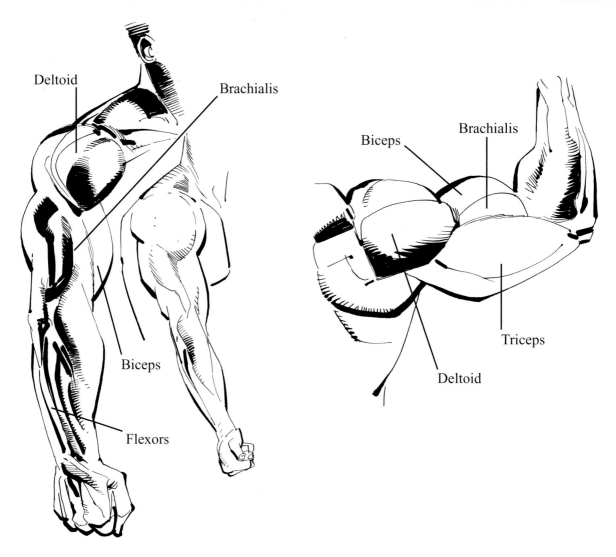

Deltoid

Brachialis

Biceps

Brachialis

Biceps

Triceps

Deltoid

Flexors

When one individual body part moves, it moves the other parts to which it is attached. In the two drawings to the left, when the hand is twisted, it forces the entire forearm into a new position.

CATWOMAN!

Tim Sale exaggerates human anatomy to create an effective and accurate rendition of the body. From *Batman Long Halloween* #5 (April 1997). Script by Jeph Loeb.

# Hands

If the face remains the most effective way of visually communicating information about the emotions and personality of your subject, the second-best way is through the use of expressive hands. The face and hands often work as a team, but there is also often a good storytelling reason for the artist to show just hands. The image should be able to communicate something about the character—it can be as simple as drawing the differences between male and female hands. Finding the right hands to fit your character is a part of storytelling.

The length of a character's hand should be roughly equivalent to the length of its head. Getting the proportions right will add a tremendous amount of credibility to your drawing. Keep a mirror near your drawing table and use your own hand as a reference whenever you get stuck.

As we discovered in the earlier parts of this chapter, it is best to work from a general shape down to a more detailed image. The palm takes up a bit more than half of the hand, but if you use the base of the pinkie as the half line, you're on safe ground. As you know, the fingers and thumb are divided into three sections each. Notice that when the fingers are splayed open, the hand appears to be in the shape of a wing or a fan; the sections of the fingers line up with each other, creating an arc.

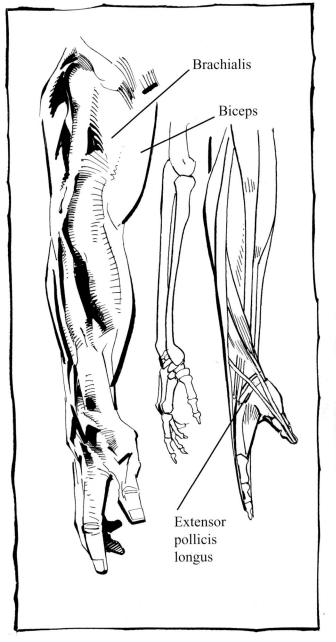

Brachialis

Biceps

Extensor
pollicis
longus

One arm in the same position seen several different ways. *Left*: The arm and hand as we know them from real life. *Center*: The skeletal view. *Right*: A view revealing the muscles and tendons.

The hand is approximately the size of the head.

Hands, like many other parts of comic book anatomy, are often exaggerated to make a point. The hand of a male character is larger and rougher that that of a female character. Some artists draw the hand in a square and angular way to convey masculinity. A woman's hand is smaller, smoother, and less angular.

In the skeletal view, the fingers seem to continue down within the palm until they meet at the wrist in a grouping of bones known as the *carpals*. Depending on the position of the hand, the carpals can form a kind of ramp on the back of the hand which serves as a transition point between the hand and the forearm.

When the hand is tipped back, the ramp flattens out against the hand and disappears.

Drawing hands well may at times involve a great deal of foreshortening. The drawings below show how dramatically different the hand can look depending on its position. Don't forget the fingernails! They are solid communicators of what the hand is doing and what position it's in.

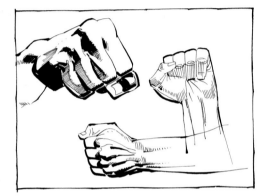
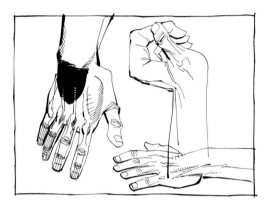

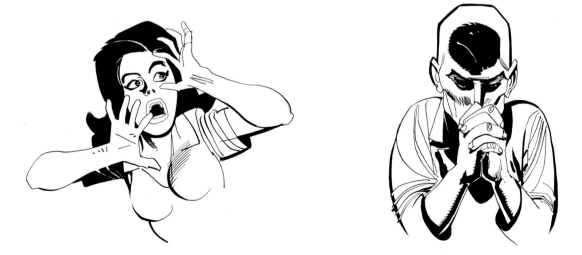

Because heads and hands are the most expressive parts of the human anatomy, they are often used together to reinforce the emotional state of the character.

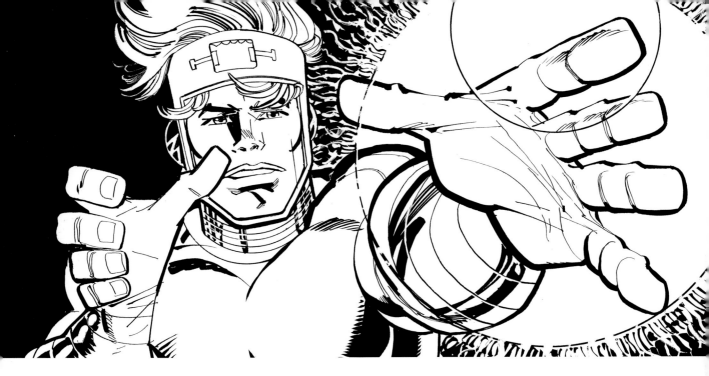

*Above*: Men's hands are usually portrayed in an exaggerated way. Comics use exaggeration, distortion, and foreshortening for both characterization and drama. One of the freedoms that artists have is the freedom to ignore reality. Distortion or exaggeration can be very effective in this medium.

*Right*: Although it appears in the muscle-and-skin hand that the fingers stop at the beginning of the palm, in the skeletal hand it is clear that the bones actually continue until they meet the carpals. Also, note that the arc of the fingertips is replicated by the arc of the individual digits in each finger.

*Below*: Like men's hands, women's hands are often exaggerated in comic book art. They are rendered slimmer and longer than reality usually offers.

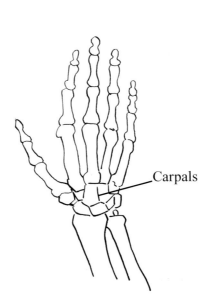

Carpals

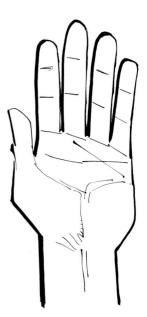

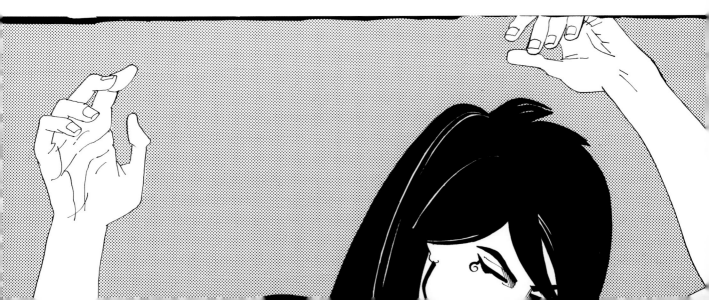

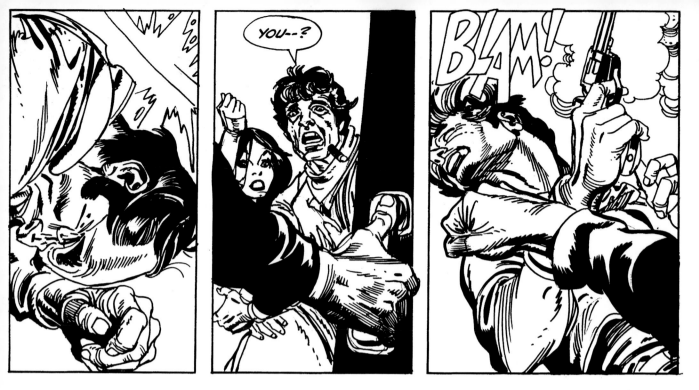

*Above and below*: These two sequences of three panels each highlight how important hands and heads are. Drawn by different artists at different times, they reveal a similarity in approach and theory. Both use heads and hands exclusively to communicate the information and action of the scene. In the sequence from *All Star Western* #4 (February 1971) *(above)*, note how specific Gil Kane is in his execution. The background figures in panel 2, for instance, have fully realized and very specific emotions that can be conveyed to the reader. The left hand of the character in the third panel is a nice contrast to the closed fists throughout most of the sequence. Gil also tells us by the open fingers that this guy is losing his grip on power and strength. Joe Kubert *(below)* keeps the focus on one head and one hand per panel in this sequence from *Our Army at War* #193 (May 1968). The tight focus and the repeating rhythm help to build tension with every punch that lands.

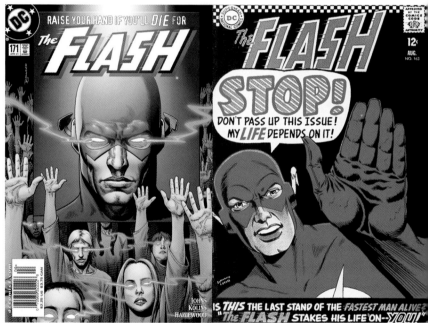

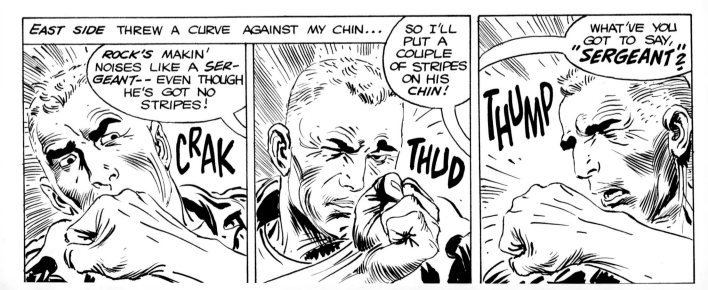

# Trunk

The pelvis and abdominal muscles are my anatomical anchor. Athletes and bodybuilders often say that the source of their strength originates from this part of the body. I try to incorporate that principle into my figure drawing. It is the twists and turns of the pelvis and torso reacting to each other that determine whether or not your figure will be active or passive, dynamic or weak. The pelvis remains a constant rectangle shape and does not change no matter what position the body is in.

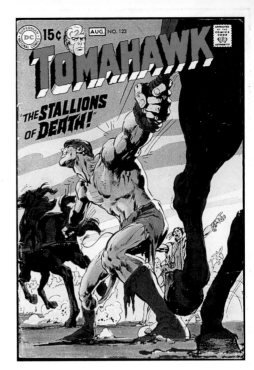

A beautiful cover for *Tomahawk* #123 (August 1969) by Neal Adams shows his incredible mastery over anatomy. Notice how the torso is rock solid. It almost appears to be a square. Adams's understanding of the human form allows him to draw the body in any position. He is able to draw anatomy correctly, compensate for the movement of muscle groups, and still exaggerate and distort with anatomical accuracy.

# Legs

Below the pelvis are the legs. There are four distinct parts to both the male and female leg: the upper leg, the knee, the lower leg, and the foot. The *upper leg* is dominated in the front by three teardrop-shaped muscles that extend from the hip down to the knee. It is also the largest mass of muscle on the leg. The *knee* is the joint that allows the leg to bend. A lot of artists draw the knee too small, especially on male figures. It is a crucial part of the leg and can be quite effective in giving the leg bulk and stability.

From the rear view, the knee is hidden from view. A series of muscles and tendons connect the back of the upper leg to the side of the knee joint, obstructing the view of the knee bone. One thing that is more clear from the back is that the legs do not start below the pelvis. They actually start right below the oblique muscles

*Opposite, middle row*: Two *Flash* covers from very different periods show us how a scene or a panel can include just a head or hand and still be effective. *Flash* #171 (April 2001) cover by Brian Bolland. *Flash* #163 (July 1966) cover by Carmine Infantino and Joe Giella.

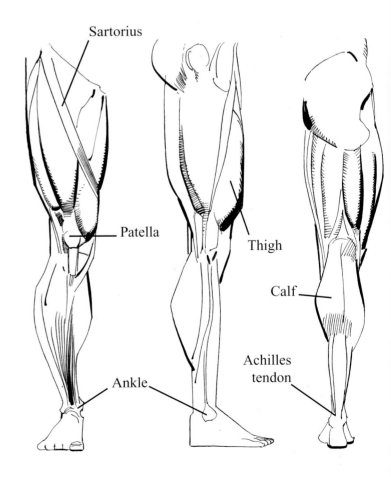

Sartorius

Patella

Thigh

Calf

Ankle

Achilles tendon

between the belly button and the pubis. Despite the commonly accepted notion that the legs emerge from the trunk and buttocks, you can see from the back view that the butt fits into the legs and the leg is the dominant muscle group.

The *lower leg*—from the knee to the ankle—has a few idiosyncrasies that never change. The calves, for instance, appear uneven from both the front and the back. Unless the leg is at an angle such that perspective and foreshortening create the illusion of symmetry, the two sides of each calf always remain uneven. The outside of the calf is always higher than the inside of the calf. At the same time, the anklebone is always higher on the inside of the leg than on the outside.

The front of the lower leg is dominated by the tibia, which is connected on opposite ends to the knee and the foot. This bone has a bit of a swerve to it, which is further accentuated by the muscles surrounding it.

The *foot* always reminds me of the bill of a duck, so I rough in that shape when I'm sketching. Like the hand, it's best drawn as one form at first; you can then attend to the toes. The construction of the foot is remarkably similar to that of the hand. Like the skeletal fingers, the skeletal toes are longer than they appear, extending almost half the length of the foot until a cluster of bones starts to form the ankle, heel, and mid-foot.

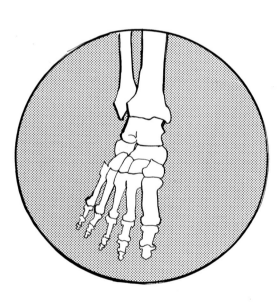

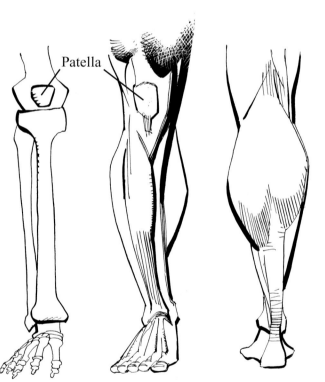

Patella

In this example of the lower leg, we see both movable and immovable parts of the body. The patella, which floats above the knee joint, is one of the few parts of the body that adjusts itself according to whether the leg is bent or straight. The ankle and calves do not change position. The inside anklebone is always higher than the outside one. The calves are the opposite—the inside calf is always lower than the outside calf.

# Movement and Balance

I've noticed that some young artists think they can disguise their lack of anatomical knowledge by always drawing clothes on their figures. This is true only up to a point; once you begin to consider movement and balance, it becomes clear that clothing is not an adequate substitute for proper drawing. How the figures you draw look while they're standing, walking, leaning, jumping, and flying is rooted in your knowledge of anatomy. It might be possible to cover up some anatomical inadequacies with clothing, but the body in action requires accuracy.

An anatomical drawing depends on more than the accurate depiction of bones and muscles. In order to present a lifelike interpretation of the human form, an artist must also pay attention to balance. A standing figure must incorporate the sway and angle of the body. The human body is almost never at an exact right angle to the floor. You will often see people resting on one foot in real life, but you will rarely see this depicted in comics because it's difficult to draw.

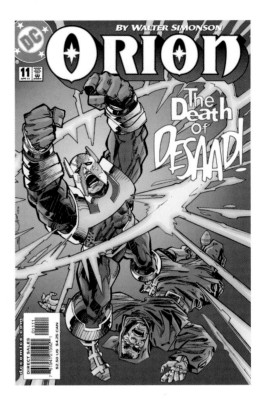

Don't be discouraged if the figures you draw are imperfect. Correctly rendered anatomy requires a life-long learning process. I'm convinced that part of the problem is the visual familiarity we have with the human body. We see them all the time, and this constant exposure makes us become oblivious to them. However, there is a way to shock yourself into a more observant state: try drawing a smaller life form. If you can successfully reduce a cat, for example, into the basic constructive shapes, it brings about a "new" way of seeing the figure. Here are some more ideas:

- Start to collect a file of anatomy references with separate folders for males, females, and different body parts. Buy muscle magazines and cut out pictures to put in your file. In no time, you will have accumulated quite a collection of photos, which will be very helpful.
- Get a Polaroid camera and ask your friends to model for you. This isn't a recommendation for a study of anatomy so much as it is a way of learning how the body moves and how clothing reacts to the body underneath. Photos like these are helpful to any artist early in his career.
- Keep a sketchbook with you if you can, or set aside a specific time out of the week when you can go out and draw from real life. I usually go to the park or a mall—anyplace where there is action and movement. Skateboarders are excellent models when you are trying to draw bodies in motion. Park yourself in a comfortable spot and start sketching.
- Take a life drawing class. They are offered almost everywhere, often at a surprisingly reasonable price. Look in your community newspaper for listings. Drawing from a live model is a great and fast way to understand the human figure.

*Top*: This cover for *Orion* #11 (April 2001) by Walter Simonson employs many of the theories we have learned. Note the exaggeration of the body positions. The standing figure extends upward toward the reader, while the figure on the floor recedes into the distance. They are at a right angle to each other. The circle of energy is used as an oval design shape. The anatomy is exaggerated but still accurate.

# FIVE
# CLOTHING

It's pretty clear that knowledge of human anatomy applies directly to the super hero genre because most super hero costumes are anatomically revealing. But what about non–super hero comics genres—science fiction, romance, adventure, Western, horror? It might seem at first that anatomical knowledge isn't necessary to draw characters for these types of stories, because they are essentially covered with clothes that do not reveal their anatomy. However, nothing could be further from the truth.

Comic book artists must meet two requirements in order to draw clothing and drapery accurately: 1) knowledge of how the body is constructed; and 2) knowledge of how clothes are constructed. Since clothing lies on top of the anatomy, it is enormously affected by the body's shape and structure. If you were never to draw a super hero in your life, a basic understanding of how the body moves and works would still be necessary to give the costumes and clothing of the other kind of figures you draw credibility.

Four basic dynamics shape the folds and wrinkles on a person's clothing:

**1. Gravity.** The natural effect of gravity makes clothing hang and pull toward the Earth, away from the body.

**2. Tension.** Try to remember that folds or wrinkles do not occur where the body touches the clothing. Clothing covering large areas of muscle tends to be unwrinkled because it is directly in touch with the body.

**3. Material.** What the clothing is made of greatly affects the type of fold or wrinkle the artist will draw. Delicate fabrics like cotton or silk will have many more small folds than something made from denim. A fur coat or a leather jacket has different types of wrinkles than a cotton T-shirt.

**4. Clothing structure.** Investigating how clothes are constructed can be very helpful in achieving credibility in your work. Many items of clothing have specific, unique characteristics. The shoulder areas of men's jackets, for example, are always wider than the shoulders that inhabit them; there's usually some padding involved that creates a special reaction when the arms are up or to the side.

Clothes react to gravity. Here, the shirtsleeve hangs from the tension point of the shoulders past the biceps and forearm (touching neither) and meets at the rolled-up cuff of the sleeve.

# Clothing and Characterization

Clothing can be a very helpful tool when you are trying to communicate aspects of a character's personality. A lot of artists spend an enormous amount of time designing costumes for the super hero part of a character's life. Unfortunately, the non–superhero characters' costumes are often given short shrift. The costume of the non–super hero is just as important as the costume of the super hero. A civilian in a comic should have as identifiable a look as the characters running around in their long underwear! The civilian outfit should be as identifiable as the super hero costume and also reveal some information about the character wearing it. This is an opportunity to say a lot about the individual visually, and it would be a shame to ignore it. Is the character good or evil, rich or poor, urban or suburban, married or single? Does he or she wear jewelry or a watch? If so, is it expensive? What kind of shoes? The more specific you are, the better and clearer the characterization will be. Don't waste any opportunity to pass on information.

Different materials react in ways that are unique to their properties. Cotton won't look the same as wool because they have different textures. A leather coat wrinkles differently than a trench coat. Silk and satin capture the light differently from other materials.

The tension points are where the arms fold and where they press against the cloth: at the shoulder/biceps junction, the biceps/forearm junction, and the elbow.

# SIX
# PERSPECTIVE

One of the most interesting challenges any artist has to face is the re-creation of a three-dimensional world on a two-dimensional piece of paper. Nothing less than the suspension of disbelief is at stake. A credible re-creation of our real-life visual experience makes the difference between holding a reader's attention and failing to do so.

## Fundamentals

When we look at early cave drawings, we can see that man was coping with the realization that what he saw in real life was difficult to translate into a drawing. The attempts at some form of perspective resulted in shapes that were in different sizes and position. Artists often made faraway shapes smaller and placed them above closer shapes. The Egyptian system of hieroglyphics ignored the effects of optical recession. Compositions during medieval times were based not on perception but on philosophy, religion, or politics.

It was not until the early 1400s that an Italian architect named Filippo Brunelleschi developed *linear perspective*, a system of organization based on geometry. Because its foundation was in mathematics, Brunelleschi's system made perspective impartial for the first time—it was not affected by politics, religion, or philosophy.

The theory of linear perspective soon led to further experimental developments. *False perspective*, for instance, is intended to contain a number of viewpoints to create a feeling of instability. *Distortion* in perspective can create a number of disorienting effects. *Forced perspective* is used to draw the viewer into the scene with greater force than normal perspective.

Besides linear perspective, there are two other ways to create the illusion of three dimensions. One is the technique of *overlapping shapes.* This is a very simple concept: A shape that overlaps another shape is closer to the viewer than the shape it overlaps.

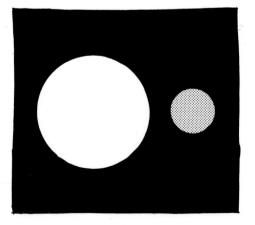 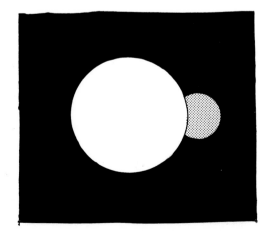

Another example of overlapping shapes, but this time as a simple form of perspective.

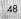

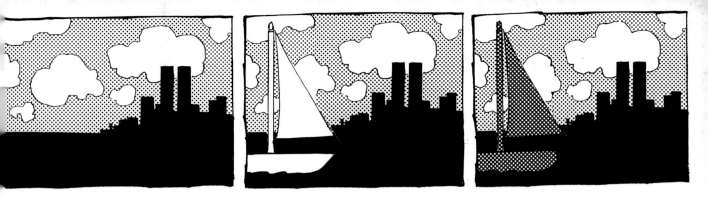

These images combine the theories of contrast and overlapping shapes to create the illusion of depth. The first shows two planes: the city and the sky. In the middle panel the introduction of the boat creates a third plane. However, the whiteness of the boat pulls it into the background because it matches the whiteness of the adjacent clouds. When we add tone to the boat, we have three clear planes.

The image on the bottom left of the facing page lacks depth. Which circle is bigger? You can't tell. Are they the same size? Can't tell that, either. A storyteller's priority is to communicate information. This image doesn't go far enough to accurately convey information.

In the illustration on the right, by virtue of compositional choice, the image reveals more. Once the shapes are overlapped, it is quite easy for the viewer to determine which is closer. We can also see if there is a size differential. This composition is much more effective at relaying information about the shapes contained within it.

The second way of creating depth is by applying the theory of *atmospheric perspective*. If you have ever had the experience of looking across a great distance, you have surely noticed that the horizon looked fuzzier and lighter in color than the area immediately surrounding you. This effect is caused by the temperature and contents of the air. Artists interpret it on paper by using two or three separate planes of tonal values. The three examples at the top of the page combine the stark contrast between black and white values and the theory of overlapping shapes to try to re-create distance.

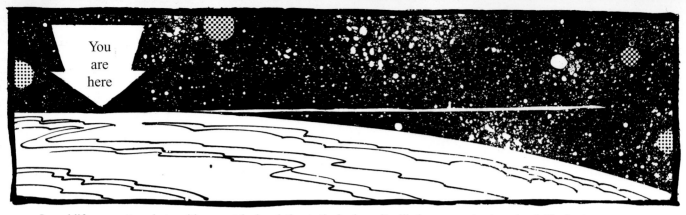

You
are
here

In real life, no matter what position you take in relation to the horizon, it will always remain at eye level. The horizon seems to follow the eye level only because we can never "see" above or below the point at which the Earth curves and drops out of sight. In comics and film, the horizon (eye level) is always the point of view of the camera, which shoots the scene.

When I was just starting to develop my artistic skills, perspective was really difficult for me. I was never that good at math, and all those perspective lines confused me; I just didn't get the concept. One day, while walking on the beach, I had a breakthrough. I remembered reading that the horizon line always corresponds to the viewer's eye level, no matter what position he or she takes. So I decided to test this idea. Sure enough, I discovered that the horizon was not stationary; as I moved up or down, it moved along with me.

Why does this happen? Because the horizon line is the farthest distance between the viewer and the point at which the curve of the Earth's surface drops below eye level. It's a phenomenon brought about by the spherical shape of the Earth and the huge disparity between the sizes of human beings and the planet.

Another way of thinking about eye level is to refer to it as "camera level." Imagine being on the beach with your camera taking pictures. The horizon moves along with the camera because it is at eye level. When people ask, "Where's the camera?," they aren't looking for something that is missing. They want to know what type of "shot" is being discussed.

## Vanishing Points and Systems of Perspective

Once the horizon line has been established, it's pretty easy to introduce a *vanishing point*. This is the name of the point on the horizon line where lines converge. The vanishing point is the spot in the distance that lines up with the camera's height and position.

Keep in mind that the horizon line and the vanishing point are completely arbitrary. There is no rule about placement; the artist makes choices based on what is best for the storytelling.

When the vanishing point has been chosen, we can start using the systems of perspective: one-point, two-point, and three-point perspective. *One-point perspective* is pretty simple. The image of train tracks on the facing page provides a good example of this.

One-point perspective only works when a side of the box is facing the camera. What would happen if the corner were facing the viewer? We would need to use *two-point perspective*. Keep in mind that the placement of the vanishing points is up to the artist. If they are too close together, the shape may look distorted—as if the camera were right up next to it. If they are too far apart, the shape looks flat. Effective vanishing-point placement depends on the story requirements and the effect the artist wants to create.

*Three-point perspective* is used when the camera is either tilted back and looking up at a great distance or tilted forward and looking down.

Once any of these systems has been established, the artist must adhere to it. Everything in the panel must line up correctly with the vanishing points on the horizon. Perspective is easiest to get right when everything in the panel follows a grid pattern—when everything is arranged to correspond to the system of perspective that is being used.

So what happens when the scene requires many haphazardly positioned shapes? Every individual shape is required to have its own vanishing point. Just remember that all the vanishing points rest on the same horizon line. This is especially true when drawing more than one person in a panel. People are very rarely arranged symmetrically so that they all line up to one vanishing point. The only exception would be a military formation. Once you deal with a normal crowd scene, there are a lot of variables to consider.

There are two ways to deal with this problem. One way is to make sure that the horizon line intersects the people at the same point on their bodies. As long as the artist makes allowances for varying differences in height, this is a very simple and effective way of keeping a crowd of people in the correct proportion. Bear in mind that this only works if the ground level is flat.

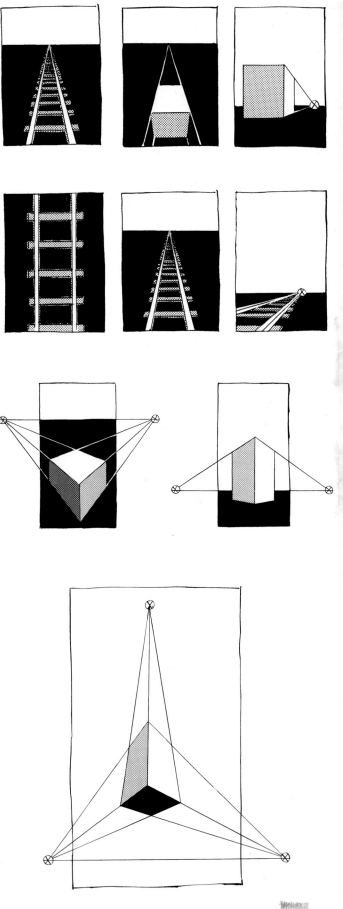

*Top (two rows)*: Once you find the vanishing point, you can draw any shape in the proper context. Remember that depth plays a critical role in creating visually exciting storytelling. Perspective is a great tool for the proper construction of a three-dimensional scene.

*Above right*: Two examples of two-point perspective. The first is a down-shot, the second a straight-on shot. These shapes are very centered in the panel, but if you were to add more cubes you would see that perspective applies to all shapes no matter what position they hold.

*Right*: An example of three-point perspective. This view shows three sides of the cube while ensuring that each angle lines up with a vanishing point. You control both the shape and angle of the object by choosing where to place the vanishing points.

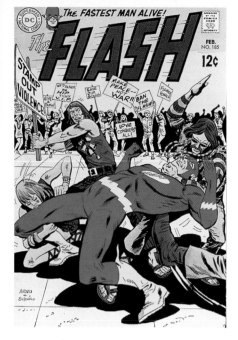

This cover for *Flash* #185 (February 1969) by Ross Andru and Mike Esposito uses simple one-point perspective. Can you find the vanishing point?

What happens if the camera is looking down or up, and, as a result, there is no horizon line intersecting the figures? As long as you can find the horizon, you can draw people in proportion. In the drawing at the bottom of the next page, the subjects are below the horizon.

When the horizon line does not intersect any of the figures at any point, try this. Draw a full standing figure in the middle of the page under the horizon line. This will be the figure upon which all the other figures will be based. Start pencilling the crowd of people. As soon as you have a second figure in a compositional position that you like, you can measure the two figures by drawing a line connecting the tops of their heads that continues to the horizon line. Draw another line from the vanishing point across the two figures' chins. If both heads meet the top and bottom of the perspective lines, then the two figures are in correct proportion to each other. If they don't, then you need to make an adjustment to the second figure. All of the figures in the panel need to be measured against the first figure.

Don't limit yourself to measuring only heads. This applies to a second figure whose entire body is not in the panel. The

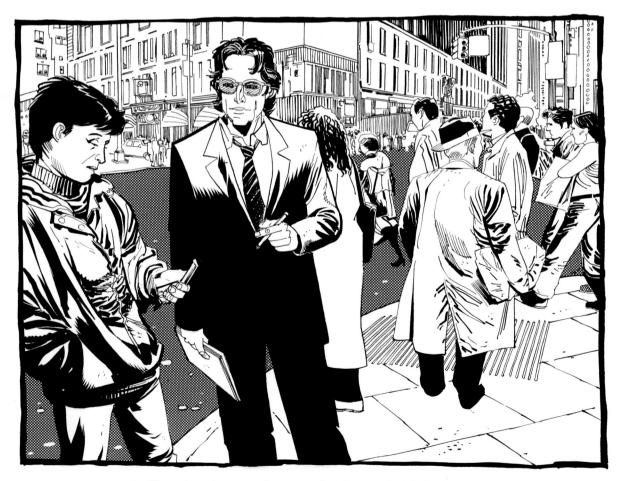

An illustration using two-point perspective. Can you find the horizon line? Notice how the horizon cuts through the crowd in roughly the same spot, taking into account the figures' varying heights.

full body can easily be measured against another full body. A seated figure must be measured against another seated figure. Draw one next to the first standing figure and use that to measure other seated figures. Experiment with this system. It might take a while to get the hang of it, but it increases a storyteller's visual options tremendously.

In addition to placing figures in the correct environmental perspective, we must make sure that the human body (with its various parts) is in perspective with itself. So many drawing problems would be solved if more beginners kept this in mind. We have seen that the body is made up of different shapes. Each one of those shapes—rectangles, cones, or circles—has perspective by itself. In order to draw the body successfully, the relationship between it and the horizon must be considered. Perspective is everywhere!

In this example of two-point perspective, the horizon is a bit lower. The eye-level cuts through all the characters just below the knee. From *Nightwing* #57 (July 2001). Script by Chuck Dixon and art by Rick Leonardi and Jesse Delperdang.

In this scene drawn using three-point perspective, the crowd is below the horizon so it could not be used for a perspective check on the people. Each figure needs to be hung on a diagonal that goes back to a vanishing point on the horizon. One diagonal runs from the top of the curly-haired guy at the left of the panel up across the page through the windowsill and beyond. Another is from the top of the couple under the awning to the top of the phone booth. Combined with the diagonal running along the bottom of the same figures, the perspective lines form a "cone" in which the figures can be placed in perspective.

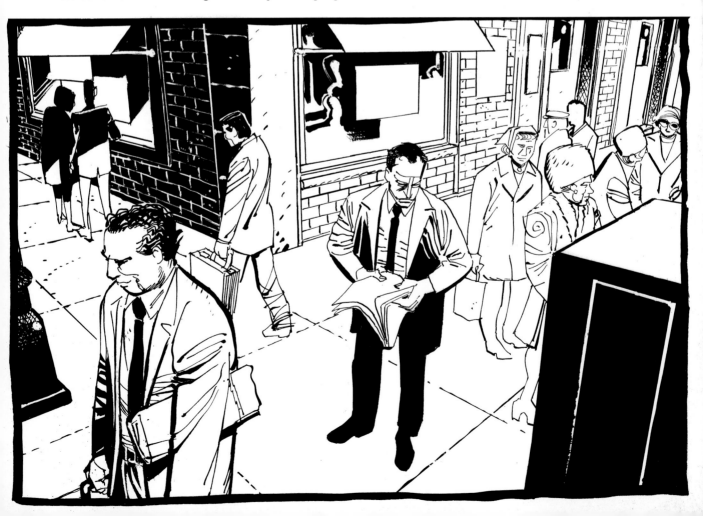

# PART
# TWO

STORYTELLING

Comic book art is judged by two criteria: the drawing and the storytelling. Most people can understand what the drawing part of comics is: the ability to draw in such a manner that the audience finds the world you create convincing. If anything within the drawing pulls the reader out of the illusion that the artist is creating—characters that look like vegetables, cars that are too outdated, an unconvincing kitchen, hands that don't look like hands—then the artist has failed as a penciller. Drawing hinges on credibility. There is only one thing that is required to achieve that credibility: practice. The more you draw, the better you will get.

That's the good news. The bad news is that artists are also judged by their ability to convey information in a clear and interesting way. There's more to telling a story than just drawing. Storytelling involves the introduction of theories and concepts that require some study and observation. Drawing can be effective or ineffective depending on the experience the artist has accumulated with such conventions as anatomy, perspective, and composition.

# SEVEN
# JUXTAPOSITION

*Juxtaposition* is a fancy-sounding word describing a simple act that produces an effect that is unique to comics. The dictionary defines juxtaposition as "the act of placing close together or side by side for comparison or contrast." While that is certainly true, storytelling involves one more goal for juxtaposition besides comparing or contrasting: *assimilation*. In sequential storytelling, assimilation means "add up" or "join." Comic book readers add up the separate panels of a page to get a larger understanding of the story. Images in panels placed next to each other automatically have a relationship because of their proximity. Why does this happen? Why can't we have two panels next to each other that are not related? The answer is in that little space between panels known as the *gutter*. The artist not only is in control of the interior images of the panel, but also suggests to the reader what happens in between the panels. The artist has the ability to do that by the power of juxtaposition—putting two images next to each other and trusting that the reader will fill in the information between the two panels.

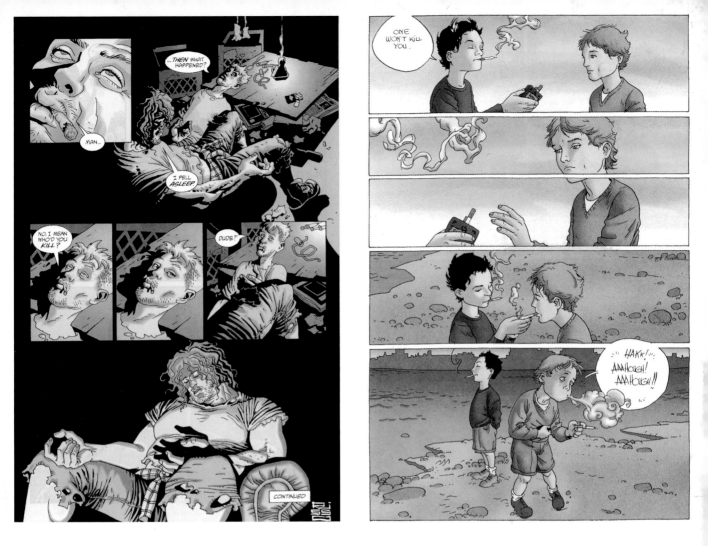

This is a unique aspect of comic book storytelling that is not found in any other medium. It requires the active participation of the reader to complete the story. He or she not only assimilates the separate images into a greater whole, but actually fills in the gaps of *time* and *action*. And all of that happens in that small space in between panels.

*Opposite, left*: A nice example of time transition from *100 Bullets* #13 (August 2000) by Eduardo Risso. Note how the bottom tier keeps the same background as the characters move through the scene. As they proceed through the panel, time passes within the scene. Script by Brian Azzarello.

*Opposite, right*: An example of transitioning to another place. The top half of this page is set inside a car. The bottom half is at a nightclub. In that small space between the two scenes, the reader fills in the action. Because of the juxtaposition of the two locales, the reader trusts that the two scenes are connected. From *Batman Gotham Noir* (2001). Script by Ed Brubaker and art by Sean Phillips.

*Above left*: A time transition occurs between panels four and five. Because the fourth panel is next to the third panel in the sequence and the panels are the same size, we assume they are equal in time. Had Eduardo Risso chosen to make panels three and four different sizes, the silent panel (panel four) would then become an indeterminate amount of time. For example, an hour could pass between the fourth and fifth panel. From *100 Bullets* #21 (June 2001). Script by Brian Azzarello.

*Above right*: This Dave Taylor page from *Vertigo Secret Files* (August 2000) shows us how to manipulate time and action. Panels 2 and 3 divide one scene in half. This technique slows down both time and action. Instead of reading it in the amount of time it would have taken to scan one panel, we are forced to look at it for twice as long. We read it as if it were two panels. Script by Brian Azzarello.

1

2

4

5

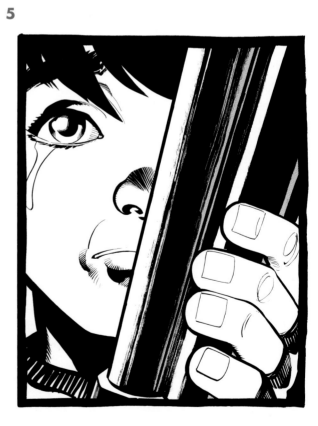

# The Meaning of Images

**3**

**6**

While we have covered the relationship of the reader and artist in the process of storytelling, there is another concept of juxtaposition to be considered. It is natural to assimilate separate images and try to make sense of them. Even disconnected images can be joined in the mind of the reader. But what of the artist's responsibility to guide the story with the selective use of images? The choice of what to juxtapose cannot be arbitrary. The exact same image can have a different meaning and purpose when the images next to it are changed. Even though the reader is a participant in the process, it is up to the storyteller to juxtapose his or her images carefully.

Let's study an example: We have before us six panels with six different images. There are many possible ways to arrange the panels; each arrangement would produce a different story. More important, each arrangement would change the meaning of each individual image, depending on which image precedes or follows it. For instance, one sequence we might consider is an arrangement that follows this pattern: 6, 1, 5, 2, 3, 4. In this choice, panel 6 would serve as an establishing shot for the story. The next panel shows a bird flying. The reader justifiably assumes that the bird is flying in the location we see in the first panel (image 6), solely because that panel precedes image 1. There is no visual evidence to support this idea—no trees or background to connect the two images. The reader makes that assumption based entirely on the juxtaposition of the two images. Image 5 is a close-up of a person with a tear running down his cheek, holding what appears to be a rifle. We can assume this man is about to fire or has already fired the weapon he is holding. We can also assume he has a relationship to the bird because the two images are next to each other. What we don't know is why he is crying.

The fourth panel in the sequence is image 2, which shows the same hunter. He seems to be raising his rifle and getting ready to shoot. The fifth panel is image 3: a close-up of the gun firing. The final panel is image 4, where we see the bird falling to the ground.

What is this story about? Even more important, what do you want this story to be about? Does this arrangement convey the information that you want to communicate? We find ourselves at this point examining the connection between design and layout choices and the efficacy of those choices to communicate your story. And even though this arrangement works on face value (we don't, for instance, have the bird falling before the gun fires—that would make no sense whatsoever), I think we can agree that this sequence imparts the information that a man shot a bird. Is that it? Is that the kind of story you want to write? Are the images juxtaposed to the maximum effect?

First of all, we learn from this experiment that we must decide what we want to say. When I initially sketched out these images for my class, I wanted to communicate a coming-of-age story in the least amount of images possible. I was hoping to communicate a loss of innocence in a handful of panels. Did the previous sequencing of panels accomplish that? I don't think so, even though it did communicate information about an event in a logical and understandable way. How can we make this story more clear?

Let's take the exact same panels and rearrange them. If it is a story about someone's loss of innocence, perhaps we can focus on that individual rather than starting out with a location or a bird. Let's start in the middle of the action and position the hunter at the beginning of the sequence. So the first panel would be image 2, the hunter aiming to fire. We need to see what the hunter is pointing at for the sake of clarity, so we position image 1 as the second panel in the sequence. The reader immediately understands the relationship of the panels to each other because of the juxtaposition of the two images. There is a relationship established because of the information in the panels and their proximity to each other. The third panel should be image 3, the gun firing. Once the gun fires, we see the fourth panel, image 4, the bird plummeting through the sky. Note the construction of this four-panel sequence. We cut back and forth between the hunter and the bird. This technique, known as *cross-cutting,* creates a bit of tension between the two subjects. When the artist shows something to the reader and then takes it away, the reader starts to wonder about the unseen subject. It's natural human curiosity that leads to a bit of tension or apprehension in the reader.

So at this point, we have established the physical action of the story: bird flies, hunter shoots. How do we get to the loss of innocence? The fifth panel needs to be image 5, the hunter crying. He is reacting with remorse and sorrow to the death of the bird, and the death of his own innocence. With a simple pull of a trigger, he has changed his life forever. Let's end up the story with image 6, the scene of the forest and lake. What was initially the establishing shot has now taken on an entirely different meaning. The extra panel now serves as a small beat at the end of a sequence which allows the reader the time to react to what the hunter is feeling, and perhaps hopefully share in it. Note how the placement of this scene at the end changes the feel of the panel entirely from the feeling it creates when placed at the beginning of the sequence. It no longer serves as just an establishing shot. Instead, the image becomes imbued with the story that precedes it. It becomes ominous and sad. The composition speaks of isolation and loneliness. Remember that in the both arrangements of images, the images themselves are exactly the same. Their meaning changes based on the nature of the images next to them. This is the power of juxtaposition.

**Exercise:** Copy the six images that we used in our experiment and see how many different ways you can arrange them. Take note of how the images change meaning depending on where you place them.

# EIGHT
# HOW TO LAY OUT A PAGE

In order to use art as a means of communication, we must first recognize that art is a language. Like any language, it has its own conventions and rules. The words you are now reading are understood because we who speak and read English have agreed on the rules of our language. Words and sentences are constructed in such a way that when we use them to speak or write, we are able to communicate with people other. I mean other people. See what I mean? The fundamental rules of the language make communication possible.

What other language systems are there? Mathematics is one. If we didn't learn the rules of addition, subtraction, multiplication, and division, numbers would be meaningless to us. It's the system of rules that allows us to understand the story of numbers. Sign language is another communication system. The ability to understand a story painted on air requires us to study and accept the principles and concepts of signing.

Artists as storytellers constantly need to answer this simple question: what is the best way to communicate this story? The layout of a comic book page serves two functions: 1) It presents the story in a series of shapes called *panels* that need to be arranged and designed in a comprehensible way; and 2) The layout pulls the eye of the reader along a purposefully designed route called the *story flow*.

When a reader looks at a comic, his or her brain first registers the page as a whole. Only then does the individual panel come into focus. Information is processed very quickly. Even before the interior image of the panel is absorbed, the viewer has already gathered some information from the shape and size of the panel itself. Let's see some of the ways storytellers can take advantage of this.

There are two ways to lay out a page: *grid* and *free-form*. In the grid page from *New Gods* on page 62, there are no variations in size or shape. All the panels are the same size. In the page from *Showcase* on page 63, Jerry Grandenetti and Dick Giordano chose to make panels different from each other, and lay out the page in a freer style. Each of these choices passes on some information to the reader without even taking the interior art into consideration.

Since all the panels in a grid layout look alike, the design of the page does not reveal much about the artwork. It also does not tell the viewer which panels are more important or how much time to spend on an image. The grid approach is considered the more difficult of the two because a flashy free-form layout can disguise artistic deficiency. The grid design fades into the background very quickly, forcing the reader to focus more on the interior images.

The free-form layout is much more of an active participant in the communicative process than the grid form. The arrangement of the panels, their relationships to each other, and their sizes and shapes communicate information even without an interior image. Since we as storytellers are in the business of conveying information, the choices we make should depend on what we want to say.

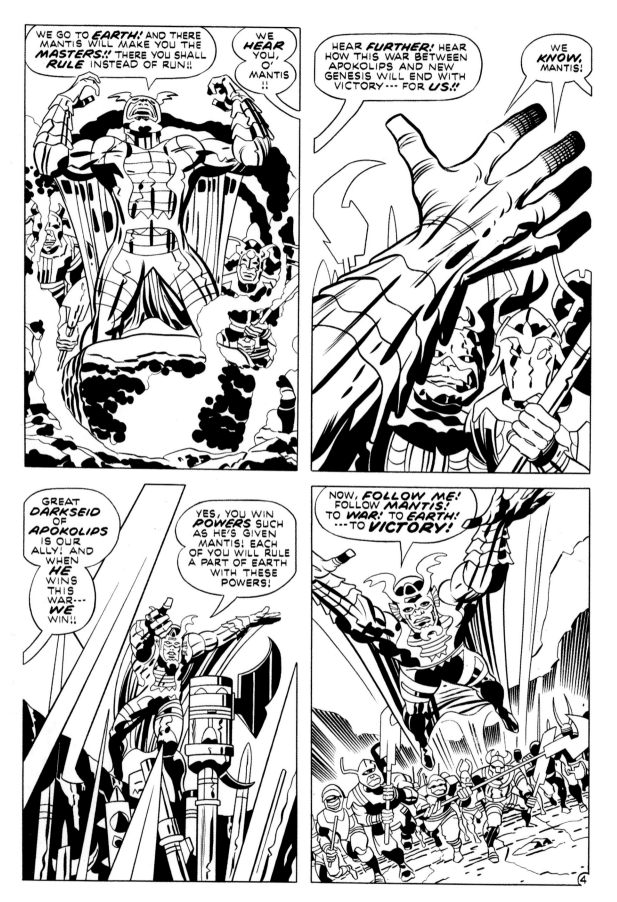

A page designed by Jack Kirby following the grid pattern. The fact that all of the panels are the same size forces the reader to focus on the interior art instead of the design of the page. From *New Gods* #10 (September 1972). Inks by Mike Royer.

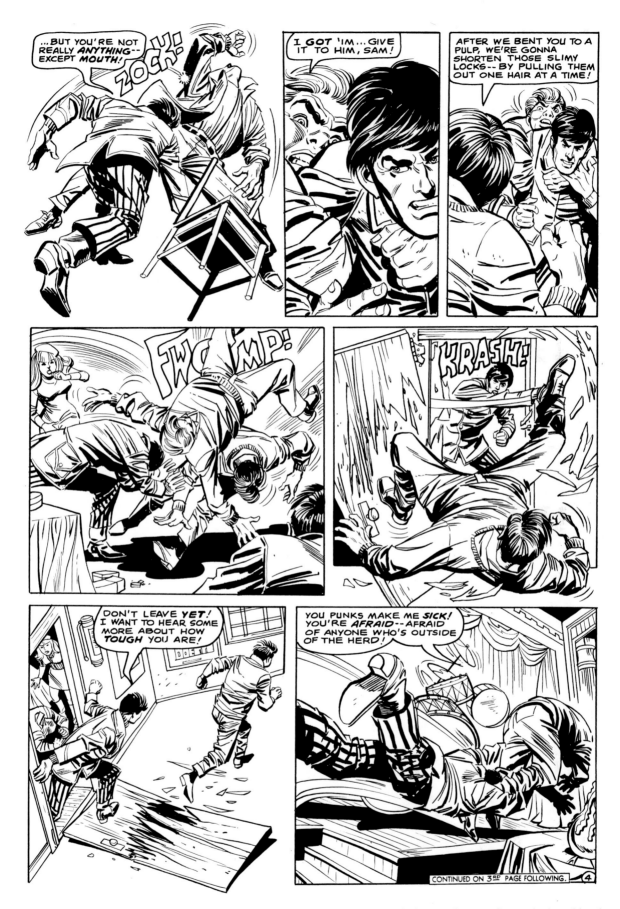

This page from *Showcase #82* (May 1969) has a free-form design. Rather than laying out the page first, as in the grid style, the panel layout becomes part of the art itself. Art by Jerry Grandenetti and Dick Giordano.

In the first three panels of the free-form layout on page 67, for example, I know that less time will be spent reading the smaller panels than a bigger fourth panel. The size of the three smaller panels tells the viewer that the information is probably less important than the bigger panel. I also know that they are probably part of a sequence because they are on the same tier most likely leading up to the fourth panel, and that the action within them is probably quicker than the bigger panels.

I know by the size of the biggest panel on the page that the information contained there must be the most important or most dramatic of the page. Because of the size, I also know that the reader spends the most time in that panel. The last two panels, because of their design, tend to be more neutral than the rest of the choices. I would bet that they follow-up panel 4 and are in some way connected to the action in the bigger panel.

The second thing an artist should consider when choosing the layout for a page is the question of whether or not the choice helps the reader to follow and understand the story. Storytellers have a

*Left*: This is a good illustration of how to force the reader into a different visual flow. This page reads top to bottom and then top to bottom again. From *The Brave and the Bold* #93 (January 1971). Script by Bob Haney and art by Neal Adams.

*Right*: This page was designed to be read down through the second panel, across the black shoulders of Batman, up the chimney and down again into the last panel. From *Gordon's Law* #1 (December 1996). Script by Chuck Dixon and art by Klaus Janson.

responsibility to take readers by the hand and lead them through the story. The artist is in charge of not only what the reader sees, but also how and when to see it.

The tendency in Western culture is to read from the left of the page to the right and from the top of the page to the bottom. In a very general way, this is the simplest version of story flow. The question that arises is whether or not the artist wants to aid that established rule of reading or choose another approach for another reason.

The Z-shaped story flow, which has a very basic left-to-right, left-to-right design, is the most typical way to approach a layout. However, there are many other layout possibilities—for example, making the reader read up and down instead of left to right. The most important element of a layout is clarity. If the panel arrangement makes where to go unclear, the reader will be pulled out of the narrative experience. The goal is to keep your audience in their seats and in your control.

*Left*: A different page design by Neal Adams forces us to read down, then quickly swerve to the right—out of the page—and then from right to left as we enter the page again. From *Detective Comics* #410 (April 1971). Script by Dennis O'Neil and inks by Dick Giordano.

*Right*: Walter Simonson uses page design to complement the flow of the action, and vice versa. The reader's eye moves up and to the right not only because of the panels' positions but also because the figure of Orion within the panels moves in that direction. Notice also how the horizon line connects panels 1 and 2, compelling us to read from left to right. The eye moves down through panels 2, 3, and 4; from right to left in panel 5; and from left to right in panel 6, finally reaching the last panel. From *Orion* #12 (May 2001).

This type of layout is called a grid.

After reading the script, your page design and panel size are your first decisions.

Ask yourself what the scene is about and how you can best communicate that to the reader through your panel choices.

What does a page layout do?
- Tells the reader what is the most important information on the page, usually presented in a dramatic and interesting way.
- Tells the reader how to read the story by establishing a story flow.
- Tells the reader how much time to spend on a panel.

The grid neutralizes the shape and size as a source of information and eliminates the participation of the layout in the art.

This approach to laying out a page is called free-form.

The artist can do a design of any configuration as long as it is clear and understandable.

These top three panels are probably read the fastest because they are the smallest and are located on the same tier.

Because this panel is the biggest, it is probably the most dramatic visual or the most significant piece of information. In most cases, it is both at the same time. The biggest panel on the page is often the anchor of the page, around which the other panels rotate. Remember that all panels are related and connected to each other.

Panel shape and size are chosen according to the information inside.

The free-form layout makes the design of the page and the shape of the panels merge with the art itself. They become one.

# Insert Panels

There are other layout choices that fall under the approach of a free-form design. One of those options is referred to as an insert panel. That's a panel that is placed within another larger panel. It can be entirely within the larger space, or it can bridge two panels by breaking the borders of both of them.

When an insert panel is placed entirely within the borders of a larger panel, it usually means it is connected to the information within that larger panel. The more important information is contained in the larger panel. For example, a hand turning on a car's ignition might be the insert in a larger panel showing the car pulling out of a driveway. The time that elapses between these two panels in the story is also shortened considerably because the insert is within the bigger image. The actions occur almost simultaneously because of the drawings' proximity to each other.

When the insert panel is placed between two panels, its primary effect is to act as a directional guide for the story flow. It leads the reader into the next panel and the next stage of the action. Remember that the most important part of your communication is clarity. If an insert panel confuses the story, don't use it. The choices you make have to serve the storytelling.

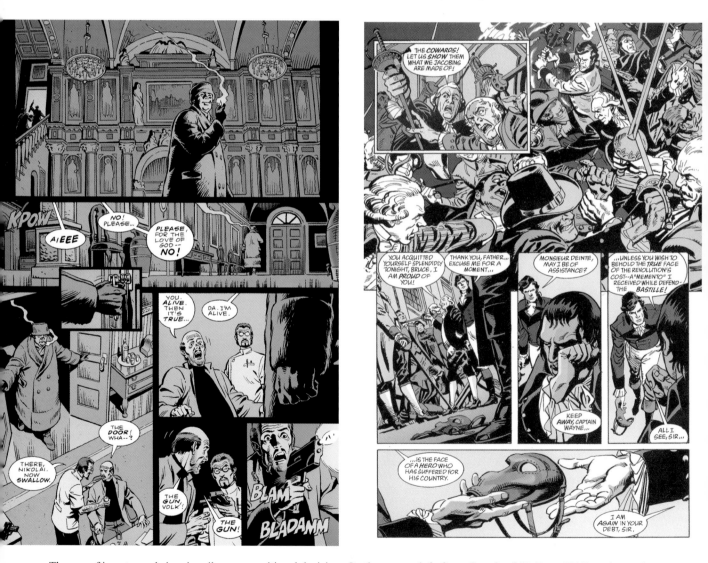

The use of insert panels is primarily a compositional decision. On the page at left, from *Gangland* #1 (June 1998), writer and artist Dave Gibbons uses the insert as a transitional panel between panels 2 and 4 by positioning the insert on the border between them. On the page at right, from *Batman Reign of Terror* (1999), writer Mike Barr and artist José García-López places the insert panel within a larger panel. No matter where it's placed, the insert panel should not interfere with the story flow. Both of these insert panels guide the reader to the next piece of information.

# Breaking Borders

One of the characteristics I've noticed in young artists is the consistent need to break panel borders. It is often the very first design experiment that occurs. Breaking borders can create a variety of beneficial effects, but like any choice the storyteller makes, there are some consequences.

In the example below, the figure becomes much more dramatic when it breaks the borders. The placement of the shape in front of the panel creates a depth and dimensionality to the scene that is highly effective. It pops out at the viewer much more than in the first example, where the figure is contained within the panel.

The problems arise when you start to consider the effects this panel may have on the panels around it. The reader tends to follow the diagonal slant of the figure and is led by it in the same way an insert panel can be used to direct the reader's eye. It is extremely important that the layout of the page serve the telling of the story. If any of the design choices confuse the reader or make it unclear which panel to read next, the layout is ineffective and a failure.

Breaking the borders of a panel with a shape creates an illusion of depth and makes the shape "pop." In this example, the enclosed shape looks awkward and confined.

# Panel Borders

There are a variety of panel borders that the storyteller can use in the process of laying out a page. The day of the single-line border has long since passed. Panel borders are now as varied as the imagination and judgment of the artist. The classic comic page has a white gutter and a thin black line around the panels. Because we have been conditioned to accept this configuration as the "normal" look for a comic, the panels do not look different enough to have any impact on the reader.

A black gutter changes the look of the page quite a bit. Besides being a departure from the classic page design, black gutters have a tendency to pull the panels inward and make the page look smaller and busier. If I choose a black gutter, I try to compensate by making the interior art less congested, giving the page an illusion of more space and air.

Some panel borders are chosen for the sole purpose of attracting more attention to a panel. The

double-panel border is a good example of that. Used sparingly, it can separate that panel from the rest of the page quite effectively. The critical factor in this case, and many other examples, is to use these types of panel borders infrequently. This preserves their unique quality and will ensure that these panels, by virtue of their contrast to the rest of the page, get more attention than other panels surrounded by classic borders. In the case of the double-panel border, you also have the option to fill it

*Top*: The comic page with a black gutter. From *Batman Black and White* #3 (August 1996). Script and art by Bill Sienkiewicz.

*Left*: The classic comic book page with a white gutter. From *Batman Black and White* #4 (September 1996). Script by Jan Strnad and art by Kevin Nowlan.

in with color. This will differentiate the panel from the rest of the panels on that page even more.

In the last 15 years or so, an even more flexible panel border has emerged: the free-form, non-ruled border. The border is not executed with a straight edge, but done by hand. It can range from a casual, hand-drawn border to a very expressive, almost violent line. This approach is often used to reflect some traumatic or earth-shattering event within the panel. The border truly becomes an extension of the interior art.

The artist as storyteller may decide to construct a page with no panel borders at all. This is particularly noticeable in Will Eisner's post-*Spirit* work. This is an attempt to design the page as a unit, rather than dividing it up into panels. If handled properly, the panel-to-panel reading experience can be smoother and absorbed more efficiently.

*Above*: A nicely designed page from *Sword of Azrael* #1 (October 1992) by Joe Quesada and Kevin Nowlan. Notice how the hanging lamp draws the eye into the first panel and how the circle is used as a design element there. The gutters of the page are black. Panels 2, 3, and 8 have double panel borders around them. The middle tier has another kind of border which establishes that sequence as having a separate identity from the rest of the page. The last panel has a bleed that guides the reader out into the next page. This design acts as a counterpoint to the hanging lamp, which guides the reader into the story. Script by Dennis O'Neil.

*Right*: This page from *Hellblazer* #104 (August 1996) is a good example of expressive free-form panel borders. Script by Paul Jenkins and art by Sean Phillips.

Panels are not passive. Their size and shape not only influence the interior composition of the image but also communicate the value of the information they contain. Individual panels interact with each other to give the reader a greater understanding of the information the artist is trying to communicate. The choices of layout and panel shape should be a deliberate decision reflecting the needs of the story. Each decision the artist makes sets a series of other choices in motion. For every action there is a reaction. Think about what your choices symbolize.

In this page, the artist combined free-form border panels with a relatively classic page design. From *JLA Annual #1* (1997). Script by Brian Augustyn and art by Gene Ha.

This page from *Orion* #11 (April 2001) does not have defined panels. It has a very strongly designed story flow that allows the reader to take more time absorbing the information. Creating this type of layout is often very difficult and requires a strong knowledge of composition and design. Script and art by Walter Simonson.

Designing comic book covers means dealing with some unique issues. Even though the dimensions of a cover are the same as those of interior pages, there are a handful of problems that arise on covers that do not appear in the interior. For example, a cover must include the publisher's logo. The UPC bar code is another compositional problem to overcome. Most artists will design the cover image around the logo and bar code, but there have been times when these items have been incorporated into the layout of the cover image itself. Changing the logo design or its position can separate your cover from all the others on the racks quite effectively. The problem with this option, as the theory goes, is that it can make it difficult to see and/or recognize the logo. Most logos are identified with the character as much as their costumes may be. To change a logo's look or position from month to month seems to be a risk in the eyes of most comic companies, one that they are not willing to take.

The cover must be approached differently than the interior art, because it has a different aim. While the interior art is focused on the telling of the story, the cover image is designed to get readers to buy the book. Usually, the cover image is not affected by any other panels. It is most often a single image that needs to succeed by itself. That means the main character needs to be seen from the front with his or her face showing. Covers that focus on the back of the hero's head have been used, but they are rare, because not showing the hero's face is not an effective way of communicating with a regular reader or enticing a new one to make a purchase.

In this nicely designed cover for *Heavy Liquid* #3 (December 1999), Paul Pope incorporates the text and UPC box into the design.

A lot of covers fall into a handful of types:

The *hero in trouble* is probably the most common type. The theory is that casual observers are more curious about the fate of the character when they see him in trouble than they are when they see him victorious and "safe." Potential threat is more interesting than certain victory.

The *pin-up* cover is becoming more and more prevalent. It consists of either a full-body or half-body shot of the hero(es) in a pleasant composition. The emphasis is usually more on the drawing than anything else. The only real difference between this type of cover and the hero in victory shot is that the pin-up focuses on the hero alone whereas the victory image might include the defeated villain.

*Above*: The classic cover where the hero of the book appears to be in trouble. Often the scenes are presented in such a manner that the hero seems to be doomed. This approach is meant to provoke the reader into buying the comic book in order to discover how the hero gets out of the jam. From *Batman Beyond* #18 (April 2001). Art by Brian Stelfreeze.

*Left*: Sometimes a cover is beautiful enough to justify the purchase of a comic, as in this Adam Hughes pin-up cover for *Wonder Woman* #166 (March 2001).

KRYPTONITE NEVER—

The *mystery* cover is characterized by the presentation of a situation that might provoke curiosity within the reader. A lot of covers in the 1960s and 1970s were built around this premise.

And then there's everything else. . . .

None of these cover types is etched in stone nor are these the only types of covers from which to choose. Covers are limited only by the imaginations of the editor, art director, and illustrator. New concepts can come from anyone and at any time. Hopefully, they will come from someone like you!

*Above*: *Superman Adventures* #54 (April 2001). Art by Mike Manley and Terry Austin.

*Right*: A classic montage cover by Mike Mignola for *Batman: The Doom That Came to Gotham* (2000). Mike often does covers in this style. They require a highly developed sense of design and can easily deteriorate into a confusing mess with no discernible focal point. Notice how the black and white relationships are specifically designed so that the image remains clear and understandable.

*Above left*: This cover for *JLA* #50 (February 2001) focuses on a group shot of the main characters. It combines elements of montage and pin-up covers. Note the strong "C" shape design that starts at Wonder Woman, moves left through Aquaman and proceeds down to Flash and Batman. Art by Bryan Hitch and Paul Neary.

*Above right*: This cover by Tim Bradstreet for *Hellblazer* #161 (June 2001) presents information in smaller individual pieces. Similar in approach to an interior page, this design is based on the theory that the reader will assimilate the images and their information to create a cohesive piece of information.

*Left*: An example of a mystery cover. Though no one is in imminent danger, the mystery of the situation should be compelling enough to provoke curiosity in the reader so that he or she feels compelled to buy the magazine. From *Batgirl* #16 (July 2001). Art by Damion Scott and Robert Campanella.

# Splash Pages

There are two kinds of splash pages, or full-page panels: the *opening splash* and the *interior splash*. The opening splash is characterized by the inclusion of the story's title and the credits of the talent involved in its creation. Some opening splashes are pin-ups, while others form part of the narrative. The latter type of opening splash can be found on any of the first four pages of a story. If a splash page appears any later than that, it should be considered an interior splash because the reader is already fairly deep into the story.

Since the interior splash is part of the narrative, it does not include the title or credits. Instead, its purpose is to illustrate a highly dramatic part of the story that can best be served with a full-page statement.

Bruce Timm and Glen Murakami do a Jack Kirby riff in a splash that is a part of a larger narrative. From *Batman Adventures Annual* #2 (1995).

# Double-Page Spreads

Double-page spreads can either be opening or interior splashes. Either way, the drama of a single image spread over the width of two pages is a very noticeable event that should be reserved for special occasions. Nothing dilutes the efficacy of a layout choice more than repeating it.

The rules of composition apply to covers, splashes, and double-page spreads in the same way they apply to compositions of any other size. The two-page spread has different measurements, but all of the theories of balance, bisection, and contrast apply. However, in interior art the theory of juxtaposition can help an image succeed because it works with other images to communicate with the reader, while full-page images must succeed on their own.

*Left*: This nicely designed double-pager is both a part of the narrative and an opening page with the credits included. Notice how the two pages are organized around a "V" shape. From *Superman* #169 (June 2001). Script by Jeph Loeb and art by Ed McGuinness and Cam Smith.

*Overleaf*: Joe Kubert does a double page in narrative continuity where he displays his extraordinary sense of composition in *Showcase* #86 (November 1969). Notice the horseshoe shape that starts on the top left of the first page, continues across the page, curves down on the right side of the second page, and comes back to the bottom of the first page. The large spear separates the two focal points: the panhandler on the left and the Indians on the right.

This device of separating focal points ensures that the reader looks at them both. A smaller example is the campfire, which divides the man from his mule and tools. This gives the reader more time to observe and assimilate the information Kubert provides.

MEANWHILE...A FAIR-SKINNED, RED-HAIRED YOUTH DRESSED IN **BLACKFOOT** GARB APPROACHES THE LAND OF THE **CROW...** UNAWARE OF THE DRAMA TAKING PLACE AT THAT VERY INSTANT...

SOMEWHERE IN THIS LAND WROUGHT BY ✱**NA'PI'S** HAND,...I WILL FIND A PLACE FOR MYSELF WHERE I WILL NOT BE SHUNNED BY **INDIAN** AND **WHITE** ALIKE...

✱"OLD MAN"... THE CREATOR.

3

# NINE
# STORYTELLING

Everyone has had the experience of telling a joke and having it fizzle—I know I certainly have. How is it that one person can tell a joke and be hilarious and someone else can tell the same joke and bomb? Since the characters and the punchline are the same, odds are that the answer lies in the *way* the joke is being told. Either the sequence of events was messed up or the timing was off, or maybe the characters were unclear or the punchline was presented poorly. Maybe the joke-teller just repeated the words but didn't commit emotionally to the telling of the joke. Whatever the problem was, it always comes down to the person's ability to organize the material and present it in an interesting way.

Those are the same criteria by which we can judge storytelling: *clarity* and *entertainment*. A comic book story must be offered to readers in the clearest way possible so that they understand the image information within each panel. And clarity is much more difficult to execute than it sounds.

In addition to being clear, the information needs to be presented in a visually interesting way. This will ensure that the reader does not "tune out" of the story. It is the combination of being both informative and interesting that makes for the best storytelling.

In addition, there is the matter of the comic form itself. By its very nature, the comic is a visual medium. Although the combination of words and pictures works together, it is the art that carries the most responsibility for the success or failure of a comic. If you were to remove the words from any comic, it would still be true to its form and remain a comic. If you removed pictures from a comic, however, you would change its form and have a book. As a consequence, if the artist relies on words to tell the story, then he or she has failed in his or her storytelling responsibilities. The art must work by itself without words. The readers have to be able to understand the story based on the pictures alone. If they cannot, no matter how impressive the drawing itself looks, the execution is a failure. A good comparison would be watching a film with the sound turned off. If you understand what the movie is about, and understand what the characters are doing, then the storytelling is effective. Every artist needs to have the standard of clarity as the centerpiece of his or her storytelling.

What does it mean to be clear in your storytelling? It means that the artist must tell us, through the visuals, *who, what, where* and *when* on every page. That's right: every page. The format of the comic demands that all information be reestablished after the opening page of a scene. It is the simple act of turning the page that makes this so essential. As the artist, your job is to continue the forward movement of the narrative without confusing the reader. If at any time the reader has to go back to find some information, the flow of the story is interrupted and the reader is disconnected from the story. This is why artists not only have to establish characters, what they are doing, where they are, and when they are in the first page of the sequence but also on every other page. There may be exceptions to this based on the requirements of particular scripts (e.g., your hero is trapped in isolation and there is no reason to show what time of day it is), but 99 percent of the time, you can and should fulfill this part of your job.

Let's explore with an example. One of the most enjoyable projects I ever worked on was a Batman story written by Grant Morrison called *Gothic*. I thought the script was unusually tight and crisp, with a very well-developed sense of visual storytelling. In issue one of the series, there was a two-page scene that to this day is one of my favorites. Except for the establishing shot in the first panel, the structure of the scene is a constant pendulum-swing between the two characters, right up to the very last panel. Because the scene was so well structured, I was able to play around in it.

The first requirement is the establishing shot on the first page. We are outside in Gotham's red-light district. We cut to an interior shot to find a sleazy guy on the phone. That combination of shots— an exterior followed by an interior—is very common at the opening of stories. The exterior shot is often followed by the interior to make sure there is no mistake about where we are. What is unusual in this scene is the introduction of a third establishing shot. Once the establishing shots are out of the way, the story picks up a bit of steam.

At the time, I was deeply interested in the storytelling abilities of the camera and how it related to movement, so when I was laying out the pages for *Gothic* I had that in the back of my head. It was the organizing factor for me. I was presented with one movement already. Mr. Whisper, the villain, moves toward the phone booth in panel 5 on the first page and panels 1 and 3 on the second page. That was required by the script. It also necessitated that the guy in the phone booth remain stationary so that he served as an object by which the reader could measure the movement of Mr. Whisper. That left the sleazy guy. So if you look at that sequence, you will notice the camera consistently moving toward him until the character realizes the absolute horror of the situation on panel 2 of the second page.

The next time we see him, in panel 4, he is in a deliberately chosen composition. The shape of the desk seems to squeeze the sleazy guy compositionally the same way that he is being "squeezed" by Mr. Whisper. It's a visual representation of the action that is occurring. I introduced the silhouette of the lamp to represent the feeling that the sleazy guy is being watched. I stuck to that theme in the last panel, too, where the windows were meant to represent eyes looking in, watching the character. The last panel also pulls back farther than it ever has in that office. The idea was to generate the feeling of isolation and loneliness that the sleazy guy is feeling.

If you look closely at the angles of the panels, you will see only one angled panel in the entire sequence: panel 5 on the second page. Even though the first and last panels have distortion in their perspective, their axis is vertical. The axis in panel 5 is definitely at a diagonal. This separated it from the rest of the panels and hopefully made it stand out more.

In retrospect, I'd like to change the establishing shot in the first panel on the first page. The distortion of the buildings doesn't work for me. I remember sensing something was off even when I drew it, but didn't listen to myself.

There was also a drawing problem that was left unsolved. If I remember correctly, the script called for the guy in the phone booth to be wearing a wig. Now that I've called attention to it, you might see that there was at least an attempt made, but no success. It's an interesting problem to deal with. How does an artist distinguish between a bad hairpiece and a bad haircut? Next time I swear I'll get it!

By showing you choices I have made, I don't mean to restrict you in any way; quite the opposite! Hopefully, some doors have been opened. These panels and pages are meant to illustrate in a simple way the range of possibilities for visual storytelling. When I sit down to draw, I know my first priority is clarity. I will do whatever I can to visually emphasize story or character points. My second

priority is to make the story interesting, and I will make choices to do that, too. Storytelling is limited only by the imagination of the individual artist. Comics can go anywhere, in any direction. How fun is that?!

The storyteller needs to read the scene more than once to make sure no information is missed. Ask yourself these questions: Who's involved? What's going on? What time of day is it? Where does the scene take place? Once you have answered these questions clearly, you can begin to pass the information on to the reader.

Some artists may be concerned that the rules or theories of storytelling might hinder their self-expression. Nothing could be further from the truth. Anyone can sit down with a pencil and paper and say that they are drawing. It's the challenge of drawing something specific that will make the artist come up with creative new solutions to new problems. Though storytelling is more complex than learning how to draw, the big secret is that it's enormously engaging and a heckuva lot of fun!

# TEN
# COMPOSITION

Composition is defined as the process of combining elements or parts together to form a united whole. That's a pretty good definition because that's what all artists do when they approach a canvas, page, or panel. Within the frame, there must be a conscious and deliberate effort to organize the shapes and spaces into a clear and entertaining unit. A composition is easier if there's only one shape in the panel, but what do you do when there are two or three—or twelve? How is it even possible to organize a panel with twelve shapes in it and still make it interesting and attractive? How do you manipulate the reader's focus? Why bother with organization at all? Why not do what I like best, just draw?

Remember that we have established that storytelling is a language with its own conventions and rules. Composition gives the artist the power to control not only *what* the readers see, but *how* they see it. We saw in Chapter 9 that it is possible to design a page so that the viewer must read the panels in a specific order. That manipulation is done through composition: the process of arranging the elements of a page or panel in a way that draws attention to the most important information.

The most powerful tool at an artist's disposal is the power to direct the reader's eye. The goal of your compositional choices is to always make the reader look at what you want them to see. The first part of fulfilling this goal is determining the size and shape of your panel. In Chapter 7 we discussed the fact that just the size and shape of a panel—even without an interior image—transmits information to the reader.

Let's look at a simple example. Say that the script your editor just gave you involves an individual whose main characteristic is depression. As a storyteller, the artist has a responsibility to communicate that information in a visual way. Showing something is always more effective than saying it. So, where do we begin?

One way would be to "draw" this person depressed. He might have a frown, be downcast, wear a lot of black, and wear sunglasses indoors. All good ideas, but are they enough? Have we used all the tools at our disposal to communicate information?

Although the look of a character is very important, is it the only way to convey an emotion? By adding composition to our storytelling arsenal we strengthen and broaden our communication abilities. One compositional choice might be to compose your panel so that the character is always off center, closer to the borders of the panel. This would visually represent the kind of isolation or marginalization a depressed individual often feels.

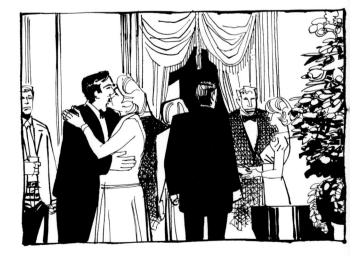

An example of visually communicating a character's state of mind through composition. By positioning the subject all the way in the left corner of the panel, I hope to convey a feeling of isolation and separation.

Or we might see parts of his body and face squished between shapes (a visual representation of being caught between a rock and a hard place). Or we could use a down-shot (in which the camera is located above the subject) whenever he's in the panel. Another idea is to try to separate him from the people around him. He might be at a café and the reader sees the immediate area around him empty but a full crowd of people sitting at tables behind and to the side of him. Composition can be used as a visual representation of what the character feels.

If you put the depressed guy in the corner of a panel, what do you do with the rest of the scene? We can use the interior structure of the panel to guide us to some of the answers. Every panel, regardless of shape or size, has a structure within it. This structure may be invisible to you at the moment, but let's see how we can bring it to light.

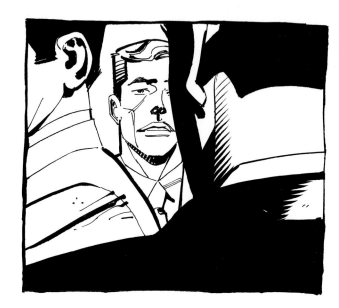

*Above*: The composition of this panel creates a feeling of claustrophobia and anxiety.

*Below*: Compositionally isolating the character is a powerful tool of storytelling. Here, we add black to obscure the subject and to make the other parts of the panel more obvious. The contrast between the people sharing their meals with others and the solitude of our character is extremely clear visually.

Where the two lines meet is the exact center of the panel. The center point can serve the artist in many useful ways. Unless there is some deliberate compositional reason that the storyteller chooses not to use the middle of the panel as the focal point, this is the spot where the reader's eye goes first. The artist plans the composition with that fact in mind. The middle of the panel is an easy and natural focal point; it is there in the panel whether we exploit it or not.

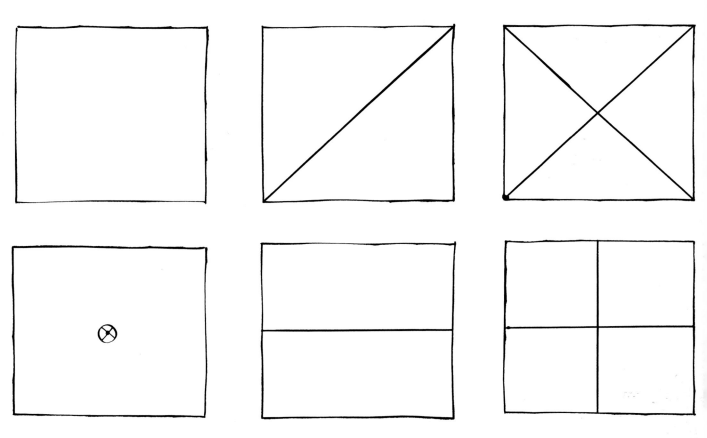

*From left to right*: To find the center point of a panel of any size, draw a line from one corner to the opposite corner. Then draw a line between the two other corners. The intersection of the diagonals is the center point. This point can also be used to bisect and quarter the panel. To do that, erase everything in your panel but the center point. Draw a line that runs through that point and is parallel to the bottom or top of the panel. You have bisected the panel. Draw another line, this time vertically through the center point, to bisect the panel again. Now the panel is quartered.

When you bisect or quarter your panel, you create guidelines to help you decide how best to arrange the shapes within that panel. If the goal of storytelling choices is to inform and entertain, how does composition help in that? We've seen an example of how an artist can use the middle of the panel as an easy focal point for the reader. By placing the most important information there instead of at the border areas, the artist pretty much guarantees the reader will see it with little confusion. However, as successful as your information communication may be, a series of panels with all of their focal points in the middle could reach a critical mass of boredom. The storyteller needs to be more interesting than that. The goal of composition is to both inform *and* entertain.

In this context, to entertain simply means that you have the reader's attention. The art should be interesting enough to hold the attention until the end. Composition is the most effective way a storyteller can keep the reader interested. There are three more ways to use composition to achieve that level of excitement: *eye movement, contrast,* and *balance.* Let's take them one at a time.

These three covers by Neal Adams all use the same composition. Draw a line down the middle of all three and see how the shapes in the covers line up around or are separated by the bisection. *Top to bottom: Phantom Stranger* #11 (February 1971); *Superboy* #153 (January 1969); and *Phantom Stranger* #13 (June 1971).

# Eye Movement

There is a theory in storytelling that the amount of eye movement is directly related to the level of enthusiasm generated within the reader. The more the eye dances across the page, the theory says, the more "awake" and entertained the reader is. The single greatest power that the artist has is the ability to control what the reader is seeing. The artist may choose to design a panel where the eye glides across the panel, directing the reader to a focal point or even to the next panel.

This theory does not only apply to the interior image of an individual panel; the panels on any given page are similarly related to each other. If, for instance, the layout of a page requires two or more panels in a single row, those panels are in a compositional relationship. Their juxtaposition can affect the interior composition of the individual panels.

Here's how to deal with that particular type of design: We can find the center point easily and put our center of attention there if we want. There are times when the storytelling will require the artist to put all three focal points in the middle of the panel. But remember that in general, we are attempting to create a bit more eye movement and excitement.

*Above*: This panel design by Eduardo Risso compels the reader's eye to travel across the image. The alternating rhythm of white, black, white, black, and white again pulls the reader from left to right. From *100 Bullets* #11 (June 2000). Script by Brian Azzarello.

*Left*: The first panel on this page from *Batman: Ego* (2000) by Darwyn Cooke is a study in balance. Divide the panel in half horizontally and notice how the image is bisected. Divide it again vertically and notice how the four quadrants shift back and forth around the axis lines in a quest for balance. The three smaller panels to the right make for a nice, calm contrast to the main image.

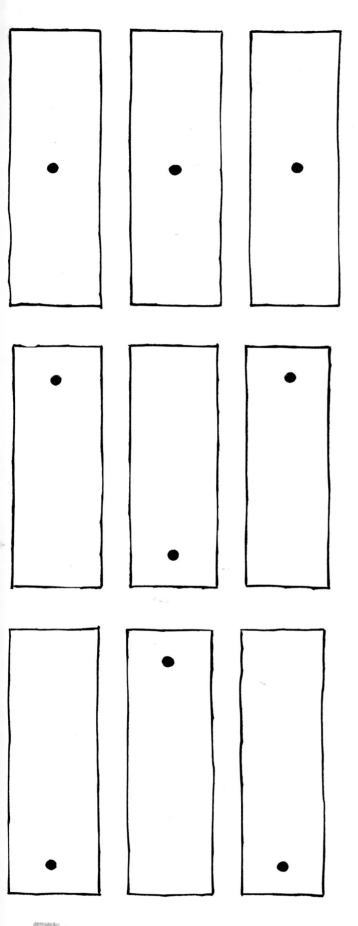

Instead of placing all of the focal points in the middle, a better composition would be to mix the locations of the focal points up. In the examples at left, we see compositions that use the first focal point to determine the placement of the second one. The placement of the second focal point, in turn, determines where the third one goes. The panels become more interesting because the artist is using the juxtaposition of different focal point locations to work for the story and keep the reader's eye moving.

Let me reinforce something here: None of this means that the artist can't compose three panels in a row with focal points cutting across the same axis. What it does mean is that you have to do that with some thought. Once you know about compositional variety, you are free to deliberately choose to tell a story in a less stimulating way. As long as there is some thought behind your decisions and you are able to justify them, you should be on solid ground with your storytelling choices.

Remember that juxtaposition means panels in proximity affect one another. The information in a multi-panel sequence can be composed with minimum or maximum eye movement. Because the focal point is in the middle of each panel, the top tier allows the eye to move across the panels. The second and third sets of panels show the focal points of the panels positioned with greater variety. In addition to moving across the sequence, the eye is forced to move up and down. This compositional choice offers greater visual variety in the layout as well.

# Contrast

If all of the shapes in a panel were the same, the image would be far less interesting than one that included a variety of shapes. When we bisect a panel, we begin to create a more interesting composition.

The top left panel below has been bisected to create two shapes that are equal in size and not particularly interesting. How can we make this composition more compelling?

Their size and shape relationships make these compositions more exciting. But contrast is not limited to size and shape. It can also be achieved by the introduction of the contrast between black and white.

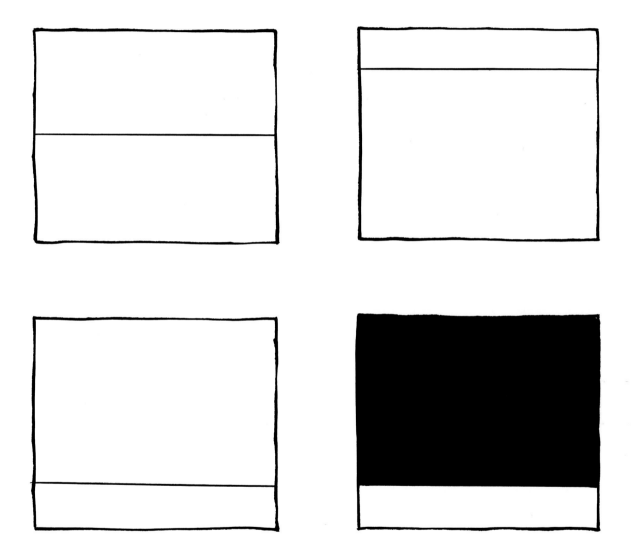

*Top left*: As we have seen, the evenly divided panel may not provide the greatest amount of excitement.

*Top right and bottom left*: Any type of contrast in spatial relationships creates a disparity that is more visually interesting.

*Bottom right*: Introducing a relationship between black and white shapes increases the contrast. Remember that in composition, *equal* is not as interesting as *unequal*.

# Balance

Balance has its own unique set of characteristics. It applies to a lot more situations than you might realize. We tend to think of something as "balanced" if its construction is perfectly symmetrical and harmonious. But there are other types of balance in the world of composition besides symmetrical balance.

## Symmetrical Balance

Symmetry is defined as being equal on opposite sides of a plane. In other words, if you split the composition at top right in half vertically, one half would be the mirror image of the other half: perfect symmetry.

Symmetrical balance

Asymmetrical balance

## Asymmetrical Balance

A composition that is asymmetrically balanced is not balanced by the size of the shapes within it, but rather by the structure of the panel. If we divided the panel above in half, there would be a shape in each section. Even though the shapes are unequal in size, the panel is considered balanced based on the presence of a shape on each side.

Draw a straight vertical line down the center of this page by David Mazzucchelli. Can you see how symmetrically balanced the page is? From *Batman: Year One* #3 (April 1987). Script by Frank Miller.

These are a few examples of how spatial relationships can be manipulated by the storyteller. In the final analysis, there may be a mathematical formula to composing a panel or a page with just the right amount of contrast or balance, but the most effective art is not formulaic. Creating a good composition is a question of following your own unique instinct. Every artist has his or her own approach. Be aware of these theories, but only refer to them as a guide to some possible resolutions to your compositional problems. Trust your instinct!

Now, let's put some of these theories into practice. You pick up your script and the first page is a scene with three cowboys on horses in the desert riding toward the camera. Seems like a pretty simple image. What is the required information—which elements *must* you include?

**1.** Three cowboys
**2.** Their horses
**3.** The desert
**4.** Movement in a particular direction

You might place your horizon line in the center somewhere and place your elements there (figure A). The sun is a shape used to eliminate any ambiguity about the focal point. Even though the information is enough to fulfill the demand of the script, is this the most entertaining or interesting way to compose the scene?

Remember that one of the least interesting compositions is one that has shapes of equal size. Right now the land and sky are equal. How about we try to introduce more contrast?

The large shape of the sky is now in a dance with the smaller shape of the ground (figure B). There's a bit of compositional tension between the two.

What else can we do? If we stay on the theme of contrast, maybe we should move the cowboys away from the center.

Of these two choices (figures C and D), I prefer D. When I look at C, my eye is first drawn to the cowboys and then moves across the panel to the negative space. I feel compelled to return to the cowboys again. In the other image (D), my eye still starts out moving

**A**

**B**

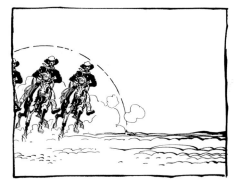

**C**

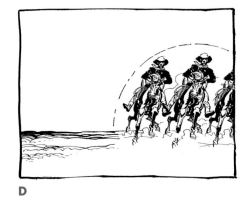

**D**

from left to right, but after it pauses on the cowboys it is ready to move on to the next image. My intellect and my gut tell me this is the one I want to use.

Studying the scene further, I find the relationship between the cowboys and the sun ineffective. They seem to be swallowed by the sun and do not stand out enough. Let's create a more interesting and productive relationship. If we break through the outline of the sun (figure E), the reader will get a greater feeling of depth and separation. The cowboys now seem to "pop out" of the sun, making the scene more three-dimensional.

Adding a foreground element to the composition creates an even greater illusion of depth (F).

What else can we do? We can experiment by adding some black and creating some contrast with the white space of the panel (figures G and H). Whichever panel you finally choose to use should be the one that tells the story best and pleases you aesthetically.

Continuing with the theories of balance and contrast, we can apply them to the figures of the cowboys themselves. They seem to have the same amount of distance between them, which might lend an artificial feel to the image. If we want to give the cowboys a more natural, spontaneous look, we can shuffle them around a bit and see if we come up with a less ordinary arrangement. Thoughtful composition, approached with deliberation, opens up an entire world of storytelling abilities. You really can go anywhere and do anything as long as you know what it is that you want to say.

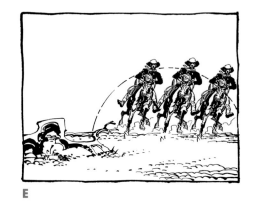

E

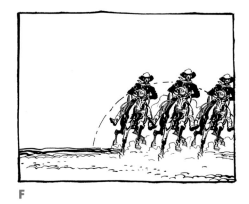

F

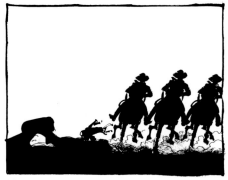

G

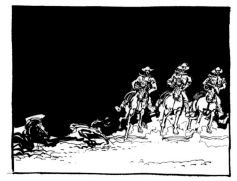

H

# The Diagonal

Another very important part of composition we have not mentioned is the diagonal. A diagonal is any line that does not echo or duplicate the horizontal or vertical lines of the panel. That's a fancy way of saying it's an angle. Once again, it's critical to understand the power of the panel. An angled line is only an angle when it is in a frame of some sort. If you draw a line on a piece of paper, it has no context unless you use the borders of the paper itself. Otherwise, the line floats in an undefined space. Once a panel is drawn around it, then the type of line it is can be defined.

Within this first panel (below) are two lines that repeat the angle and direction of the panel borders. In the second panel, there are also lines which mimic the structure of the panel border, but there is one diagonal among them. Because it does not echo the horizontals and verticals of the border, that diagonal really stands out compared to the lines that are parallel, which tend to fall back into the panel. The diagonal breaks the established structure of the panel, so it "pops out" of the frame. This leads us to our first conclusion: if you want something to be more noticeable, draw it at an angle.

We can apply this theory to our cowboy panel. Put the figures at a bit of an angle and see what happens. I think the angle of the cowboys, contrasting with the verticals and horizontals of the panel border, gives the focal point of the panel a better chance of being noticed. Directing the reader's eye is a necessary part of storytelling and anything you can do to help that makes the work that much more clear and understandable.

The diagonal is also the line that has the most "movement" to it. Since it stands out from the rest of the panel, many artists will build actions upon diagonal lines. There are plenty of times when the construction of an action may look perfectly fine parallel to the borders, but a diagonal will be more noticeable. In the image at the top of page 98, Batman is throwing his Batarang across the panel. The artist has fulfilled his script requirement for information, but how about entertainment? Is this the most interesting way to handle the scene? In the image at the bottom of page 98, the action line is at a diagonal. Notice how the action is more obvious. Drawing the panel this way has the further advantages of both providing a close-up of what Batman is throwing (clear storytelling) and creating a foreground and a background, which gives the reader an illusion of depth. The panel is also quartered, which adds a bit more compositional complexity.

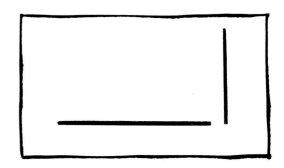

The horizontal and vertical lines in this panel are not very striking because they replicate the horizontal and vertical lines of the panel borders.

Introducing a diagonal into the same horizontal and vertical panel makes the diagonal the most prominent line. In the land of horizontals and verticals, the diagonal is king.

In addition to the diagonal being very useful for action and movement, it can serve yet another purpose. At this point, it's been established that moving the reader's eye is necessary for good story-telling. The diagonal can help a lot in this area. It is often used to lead the reader to the focal point. Using the angled line in this manner is almost a subliminal suggestion to the reader, but it never fails if used with some thought. In the image at the top of the next page, for instance, the shadow, which is at an angle, leads right to the two characters. It points to them and frames them at the same time. (The fact that there is a black shape behind the heads also makes the shapes stand out more because of the contrast between black background and white foreground.)

Diagonals can create a greater sense of depth and three-dimensionality in your work. Using the

diagonals of perspective, for instance, the composition below seems to pull the viewer into the panel. This is also the fundamental concept behind the use of blast lines. Blast lines accomplish all of what perspective diagonals do, except in a minimalist way. They point to the focal point of the panel and also create depth. (Note that blast lines are heavier at the borders and thinner toward the end of the line.)

The more time I spend as a storyteller, the more I am convinced that composition is everything. It is the essence of what I consider drawing to be. Drawing *is* composition, and never more so than in sequential image storytelling. It is the foundation of the ability to communicate in a visual way. No matter what is drawn inside a panel, a composition is created. It is there whether or not we want it to be, so it's in any artist's best interest to recognize it, learn from it, and make it work in service of the story.

# ELEVEN
# SHOTS AND ANGLES

Some of the most effective tools a storyteller has to communicate with the reader are *shots* and *angles.* A panel's shot and angle contain an incredible amount of information about state of mind, drama, and mood.

The artist's primary responsibility in a panel is to convey the pure and simple facts of the story—the plot. If the scene specifies that three cowboys are riding toward the camera, that needs to be shown in a clear and understandable manner.

At the next level of storytelling, the artist provides visual clues to help the reader gain a deeper understanding of the information being presented. For instance, three cowboys riding toward the camera can be drawn to be a simple statement of fact and nothing more. In this case, the artist would choose a shot that is neutral—something that won't convey more information than is necessary. A straight-on, non-tilted composition would work nicely.

A woman opening a package could also be neutral as long as there is just the need to show the facts. But what if there was a bomb inside the bag? Should the storyteller compose the panel in the same way? What could he or she do to make the panel more interesting and informative for the reader—perhaps to convey the woman's emotional state? This problem is solved with the proper use of shots and angles.

Before we define shots and angles, let's spend a moment on the word camera. Everyone knows that a camera is a device with which we can take photographs. When you look at a comic book, it can be helpful to imagine that all of the panels were photographed instead of drawn. For each panel, try to imagine where the camera is positioned when the picture was taken. It might be low to the ground, or up high and tilted down. It could be very close up or very far away.

Thinking about drawings in terms of the position of an imaginary camera is a technique that will broaden your abilities as a storyteller. Most of the images within a panel are *objective* shots. That is, they are constructed with an objective camera's point of view, as opposed to the subjective point of view of a character. Keep in mind that the camera's position is the same as the reader's. The artist chooses an angle or shot, but each reader sees the image through his or her own eyes. Decisions about angles and shots are deliberate. Every shot or angle—even a neutral one—conveys something particular.

## Shots

The word shot refers to the distance between the camera and the subject. Let's see what the specific shots and angles are and what meanings they can have.

## Establishing Shot

The one shot that is mandatory is the establishing shot. In it, the reader learns enough about the location of the scene to understand where the action takes place. Unless there is a specific reason not to place it there, the establishing shot needs to appear at least at the beginning of every scene. Every subsequent page should also reconfirm the location with at least one reestablishing shot. How much of the location to show in these later shots up to the artist—it can be presented as a close-up, from far away, etc., but the location must be reinforced on every page at least once because each page is physically separated from the other pages. Constantly supplying the "where" of the story allows the reader to focus on the narrative instead of questioning the location of the action.

## Extreme Long Shot

For this shot, the camera stays very far away from the characters—they may not even appear in the panel! If they do, they are probably unidentifiable, and their identities will be established in the following panel. The extreme long shot focuses on locale, a panoramic view of the town or city, or even the entire planet. It is often used in conjunction with the next panel, where the camera gets closer to the subject. The shot is often used to convey a character's isolation or the grandeur of the surroundings. It can be quite dramatic in establishing a particular mood or rhythm.

## Long Shot

This shot is also taken from a distance. The characters, if they are in the panel, are quite visible, but they do not dominate the composition. While the camera is close enough to easily include the full bodies of the characters, it is far enough away to focus mainly on the location.

## Full Shot

In this shot, approximately the full length of the body is shown. A modest amount of background might be present, but the focus is definitely on the characters.

## Medium Shot

We are close enough now to see only about half the body. There may be an indication of the background, but that might not be necessary. Often a shadow or black shape will be sufficient for the background. The focus is definitely on the character or characters.

## Close-Up

This is a shot showing the character from roughly the top of the shoulders to the top of the head. The entire face and head is almost always shown. No background with any detail is needed here; a simple black or white background is often more than enough. Too much background detail will distract from the focal point of the panel.

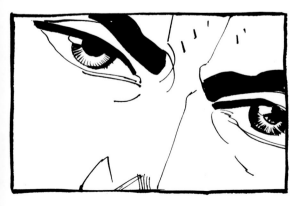

## Extreme Close-Up

This is a rather intense shot because it brings the reader right up to the character's face, which takes up the entire panel. The extreme close-up is used when the storyteller wants the audience to "move in" on the character in a very intimate way. The camera's (and reader's) proximity to the character makes this an extremely dramatic shot.

All of the shots we've seen so far have been objective—neutral. It is as if there were a camera positioned in the action somewhere, taking pictures. The majority of shots in both film and comics are objective, but there are some shots that are not. These shots are the exact opposite of an objective shot—they are *subjective.* A subjective shot shows not what the camera sees, but what the character sees. Imagine a scene that takes place on a rooftop. Our hero is hunting for the bad guy. We see him examining the rooftop for clues in the first panel. That is what the camera sees, so it is an objective shot. Our hero sees blood on the roof. The artist chooses to show the blood on the roof. Since that is what our hero is seeing, that is a subjective shot. The reader sees what our hero sees. This is a great way to throw the reader into the middle of the action. At least for the duration of the subjective shot, the reader becomes the character.

It's important to consider a shot's impact on the reader. Using nothing but long shots or objective shots not only makes the visuals boring because of the lack of variety but keeps the reader at a "safe distance" from the story. As a storyteller I know that I do not want the reader to be distant, safe, or secure. I want the reader to be as close to the action as possible. I want the reader to be involved in the story as much as possible. The closer the camera moves in to the action, the more involved the reader feels. Using a subjective shot gets the viewer even more involved because he or she sees the scene through the eyes of the player in the story. It is almost as if the events that are unfolding are happening to the reader.

One of the single most effective ways of holding the audience's attention is showing them something they have never seen before. Anything that is new or out of the realm of everyday experience has a greater chance of being interesting. We all become immune to our surroundings and our friends because we see them all the time in exactly the same way: at eye level. What we are used to seeing all the time loses its visual impact. Did you ever have the experience of lying on the floor in a familiar room and marveling at how different everything looked? Or climbing to the roof of your building and seeing your neighborhood from a different perspective?

# Angles

If camera shots are differentiated by the distance between the camera and the subject, then camera angles differ based on the position of the camera in relation to the horizontal and vertical lines of your panel. Here are some examples.

## Tilted Angle

In a tilted angle, the camera is at a diagonal from the horizontal and vertical lines—tilted either left or right. This suggests at least two things:

**1.** Something about this scene is out of the ordinary because there isn't the typical horizontal-vertical right-angle relationship.

**2.** Just as a horizontal line creates the feeling of stability, the angled line suggests instability, movement, and uncertainty. An illusion of dizziness is conveyed.

A scene showing a character reacting in shock is almost always drawn using a tilted angle in order to convey the feeling of surprise.

*This page*: In the context of horizontal and vertical panels, the tilted scene stands apart from the other panels. In the example above by Frank Quitely, from *JLA: Earth Two* (2000), the tilt is used for dramatic effect. In the bottom panel by Bruce Timm and Glen Murakami, from *Batman Adventures Annual* #2 (1995) the tilt tells us something unusual or unexpected has happened or is about to happen. Note that the tilt is an extension of the diagonal theory already discussed.

*Opposite, top*: In this powerful up-shot from *Orion* #2 (July 2000), Walter Simonson employs several theories to make the figure stand out as much as possible. A shape that dominates the page, the tilt of the figure, the up-shot used to communicate strength, and the exaggerated size of Orion's right hand all combine to convey strength and power.

*Opposite, bottom*: This page by Pascual Ferry and Walden Wong is very effective. Not only does he use the down-shot in the last two panels to indicate defeat and loss, but through his composition he makes the reader's eye move downward, mimicking Superboy's descent into that negative state of mind. From *Superboy* #86 (May 2001). Script by Joe Kelly.

## Up-Shot

In the up-shot, the subject matter is above the camera, which is therefore tilted up. A shot like this usually relates to power or victory. The camera is in a submissive position, the subject towering above it. You'll often see the up-shot when a hero or villain is introduced in a story. These types of characters are always invincible in their first panel, so an up-shot is often used to convey their strength. It can also be used very effectively in horror stories as a creepy effect. Combined with a tilt, up-shots can be very dramatic.

## Down-Shot

In the down-shot—the opposite of the up-shot—the camera is above the subject, looking down. This shot is most often used to communicate defeat and powerlessness. A good example is a scene in which a hero is momentarily defeated by his enemy. In that case, the down-shot allows the reader to see the hero from the villain's point of view. The down-shot is also used to convey isolation or loneliness. The character is at a distance from the reader—remote, alone, and unreachable.

The associations with shots and angles described above are not absolute; it is possible to choose one just because you like the look of it. However, you should do this with caution, because certain shots and angles have become cultural standards that are universally accepted as having specific meanings. The audience will react to them—even if it is only on an unconscious level—and this can make things confusing if you are trying to convey conflicting information. To a storyteller, clarity is the first and last goal. Although some of your choices may be made on purely aesthetic terms, it is very important that you be aware of what they can mean to your readers. The one requirement for effective storytelling is conscious and deliberate thought. Make your choices based on knowledge and experience and you will be far less likely to confuse your audience.

An easier way to think of this is to establish what is called the *action axis*. Imagine the camera above the couple, looking down at them. Draw a straight line through the table, Howard, and Deb. This is the action axis. The camera must stay on one side of that line. It can move to any position as long as it does not shoot the scene from the other side of the axis. The point of this approach is to provide consistency for the readers so that they never get confused about which character is speaking or acting.

The storytelling rules that govern the choices of movement within a sequence apply not only to the movement within a panel and the placement of characters in relation to the background, but also to moving objects that travel over the course of many panels or pages. The waiter serving Harold and Deb, for instance, would always have to enter and leave from stage left. If a train is moving from left to right in the establishing panel, it must move in the same direction throughout the sequence to be consistent. If we cut to the interior of the train, it should still be moving in the same left-to-right direction. If we show the wheels of the train, they, too, should be moving from left to right. To insert a shot of the train going in a different direction (i.e., right to left) would make the readers think that they are looking at an entirely different train.

With directional consistency, we are working at a very basic *structural level*. This level of thinking requires that you strip away all the drawing and detail and operate in a place where there is nothing but panels and shapes—but the story is still understandable to the reader. The opposite would be working on a *cosmetic level*. This level includes the possibility of drawing two trains differently enough that you hope the reader can differentiate between them. But storytelling can't rely on hope. It depends on deliberate choices that communicate the information and the ability of the artist to make those choices work.

A simple but excellent example of maintaining consistent directional movement is the opening sequence in the film *The Silence of the Lambs*. The first shot is of the environment surrounding FBI headquarters in Virginia. The camera moves from left to right (already establishing the movement) across the trees and picks up Clarice running in the same direction. The director keeps her moving in that direction, even though some shots are angled a bit and she has to run through an obstacle course. Another agent enters the frame from the right side (telling us that he was not following her but came by a different route). He tells her to return to headquarters. She then runs from right to left (which tells the viewer she is going back) until she sees the building. Any change in any part of that sequence would have given the wrong information to the audience. When movement isn't consistent, it's noticeable. When it works it should be invisible.

Movement created by an action works best when it works on a structural level. The problem is to create the illusion of movement in a medium that doesn't have the capacity to show movement. It is the responsibility of the storyteller to create that illusion as convincingly as possible. A structural approach relies heavily on composition and design. Cosmetic applications disregard the power of design and try to make up for the failure of solving a compositional problem like movement by applying superficial additives like speed lines.

In the first image on page 110, the shape in the middle of the panel does not look like it's moving at all. It is a convincing portrait of a rectangle at rest. The second image, by using the structure of the panel and the relationship of the rectangle to the panel border, implies movement on a purely compositional level, with no speed lines or other additions. We can introduce these structural insights

Notice how Neal Adams handles movement on this page from *Deadman* #6 (October 1985). In the first two panels the characters move from left to right. In the third panel, the movement is in transition. We see one character moving his position to the left, the other in a neutral stance facing the camera. In the final panel the characters remain in the same positions relative to each other that they held in the previous panel. Script by Robert Kanigher.

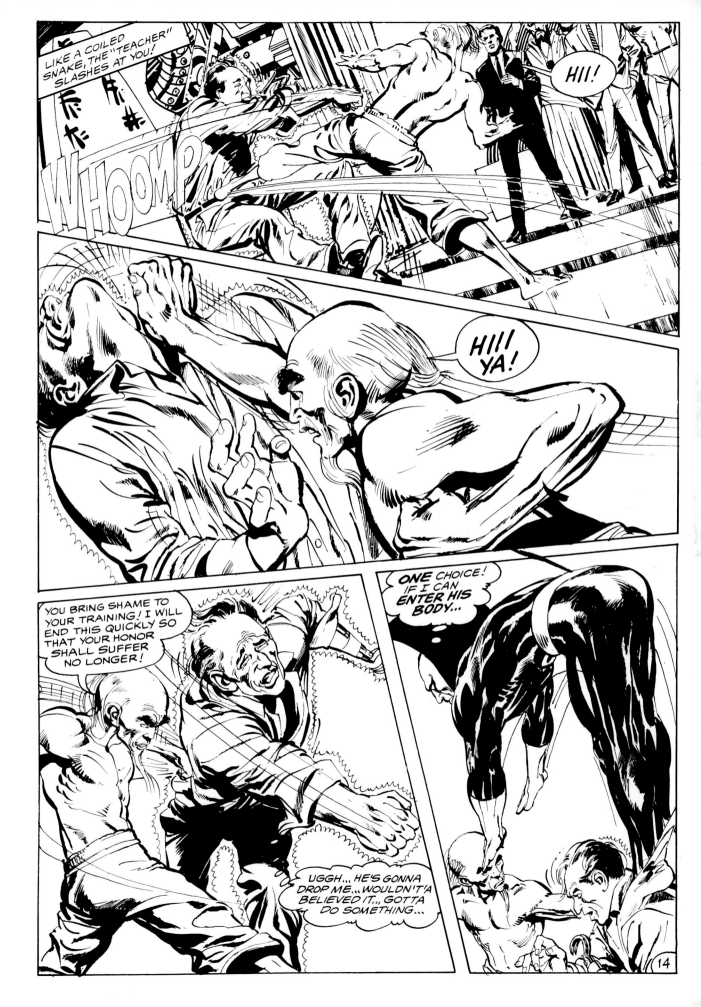

onto our drawings and see that it is much more powerful to work on this fundamental level. We can then add speed lines and smoke to reinforce the structural decisions that we made first. Remember that working on a structural level like composition and design is always more effective than adding cosmetics onto a poorly designed panel. You can always add speed lines later.

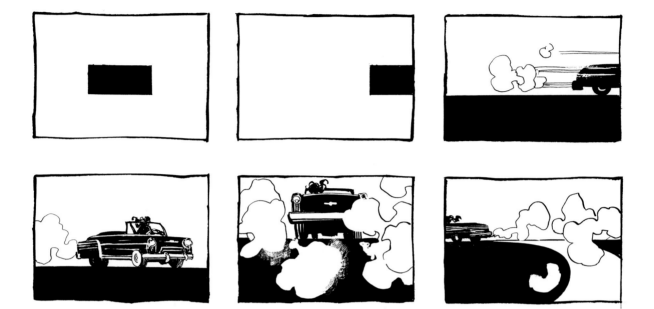

*Top row*: A shape in the middle of the panel pretty much just sits there. If we compose the panel so that the same shape bleeds off the panel, it not only makes for a more interesting visual, but suggests a bit of motion. In the last panel, we can change the shape to a car and see how effective it is to use the panel borders and the imaginary space beyond them for good storytelling.

*Bottom row*: The ability to change the direction of a moving object relies on the introduction of the neutral panel. In the first image we see a car moving from left to right. The second panel uses a neutral shot—a panel in which the action and movement is coming either toward or away from the camera. Now it's okay to change the direction of the car to one that is different from what is seen in the first panel. Without the neutral panel, the changes would be ineffective.

One of the most basic concepts of movement in comics is something most of us take for granted: the way we read. In the Western tradition, we read left to right, top to bottom. In Eastern cultures, it is exactly the opposite. Knowing how the audience reads is an important consideration for your storytelling. Since we in the West read left to right, any movement that is read left to right will be read more quickly because the readers are used to reading in that direction. When we move from right to left, it slows the action down because it goes against our conditioned method of reading.

There are going to be times in the storytelling where the artist may want to manipulate the reader by slowing down the reading process or even bringing it completely to a halt. The key to this lies in right-to-left movement. An entire page of right-to-left panels will be read more slowly than a page of left-to-right movement. There is nothing right or wrong about the movement choices an artist makes as long as he or she makes decisions deliberately and consciously based on the continuity needs of the story. Movement is a part of a greater whole that the artist presents to the reader.

Having said that, there is one loophole in all of this talk of consistency and continuity. There is a way to change direction when movement is being shown in a series of panels. I'm talking about the

shot that is going neither to the left nor to the right, but is instead moving toward or away from the camera. In a situation where only one direction has been established, it is possible to change direction with the introduction of the neutral shot.

In the first panel on the second row on page 110, we see the car moving from left to right; in the third, it is moving right to left. This switch is made possible by the introduction of a neutral shot, which acts as a bridge between the other two panels. The second panel allows the reader to clearly connect the first and third panels by showing the moving object in a neutral position.

There are other reasons to inject a neutral shot in the middle of a movement besides the need to change direction. You can use it for the sake of visual variety for instance. No matter how long or short a sequence might be, the artist still has the responsibility of being interesting and entertaining. The artist will need some contrasting shots and angles to mix up the consistent directional movement. Variety is key to maintaining the reader's interest.

A neutral shot can also be more engrossing than a left-to-right or right-to-left movement. When the neutral shot comes at the reader, he or she sees the scene subjectively and may even feel a greater sense of involvement or threat from the approaching object or objects. When the shot shows the object moving away from the camera, the reader may feel relief that the implied danger is over. In either case it puts the reader in the middle of the action, which is always a sign of good storytelling.

Storytelling is largely based on logic. Movement and direction are both part of the more logical components of storytelling. You might be able to follow the action you are trying to draw in your head, but if the scene is difficult or complicated, draw the action axis from overhead and check to see whether the action stays on one side. Continuity and consistency are extremely important in order to maintain the flow of the storytelling.

On this page, Steve Rude and Bill Reinhold employ a neutral panel to change the direction of the Guardian's actions. The first panel shows him moving from left to right. The second is a neutral shot. In the third, he changes direction. The last panel shows the character moving in a direction that is consistent with the direction in the previous panel. From *Legends of the DC Universe* #14 (March 1999). Script by Mark Evanier.

Notice how the characters in this page remain locked into their directional relationships without any loss of visual variety or excitement. Bisect the panels horizontally and/or vertically and see how Lee Weeks designs his images. From *Batman Chronicles: The Gauntlet* (1997). Script by Bruce Canwell.

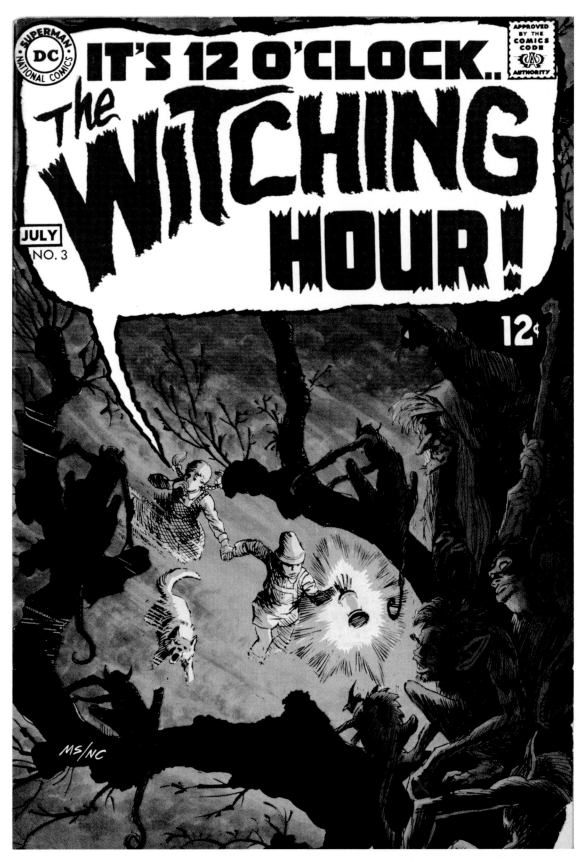

Here's another fine example of composition by Mike Sekowsky and Nick Cardy. Not only is the cover for *The Witching Hour* #3 (July 1969) perfectly balanced using the theory of bisection, but the circular design centers the kids and cat while gently leading the eye to the gremlins on the right.

# PART

# THREE

PENCILLING

Once the artist has an awareness of the skills needed to draw and the methods of storytelling to arrange the artwork in an understandable matter, it's time to begin the footwork! Getting your work into the hands of an editor or art director is as important as developing art skills. The only way to continue the opportunity to draw comics is to earn enough money to secure the comforts you need to do so.

There are three facets to this part of becoming a comic book artist. The first goal is to break into the comic book industry: to get your work in front of the eyes of someone who can help you. If you have a plan for developing your artistic skills *and* a plan to show your work, you will be ahead of the artist who does not. Remember that no matter how good you think you are, you need to show your work.

The second goal is to develop healthy working and business habits. This means, for example, not waiting until the last minute to start a job. An artist needs sufficient time to research and prepare for a job. Good business habits include meeting an agreed-upon deadline for a project. Besides the quality of your work, there is nothing as important as being timely. Good communication between the artist and the editor is also very important.

The third component of becoming a successful comic book artist is your personality. I have been surprised throughout the years at how important this is. It affects everything from your ability to absorb criticism to the relationship you have with your editor. The only way I have found to facilitate this part of the artistic process is through honest introspection. For instance, understanding that you may have an unreasonable reaction to criticism can be very helpful to developing your talents. Your ability to learn depends on how open-minded you are.

There is one other aspect of being an artist that no one can teach: passion. We can hope to inspire it, but it cannot be learned. The knowledge presented in these chapters can give you an understanding of the craft of art. A good craftsman weaves an accomplished, technically correct story. But great stories are realized through the combination of skills and passion. Don't underestimate passion's power. It can help you to overcome many barriers. You must commit yourself to this profession to overcome the challenges that will lie in your path. Find your passion and you will find your success.

# THIRTEEN
# PROCEDURE

Although every artist adds his or her own personal quirks to the process of producing art, I've noticed many of the fundamental steps remain the same. This chapter is a combination of what I have learned from other storytellers, what I consider to be effective, and support for those "personal quirks."

The first thing I do when I get a script is read it several times to ensure that I don't miss any plot details. The longer the script, the more readings it takes to absorb the story. Once I understand the action and events as presented by the writer, I search for a way to contribute my own opinions or feelings about the characters. I usually try to find a symbol, motif, or visual theme that I can play with in my storytelling. For example, a few years ago, after writing and drawing a few stories that had food in their plots, I realized that to me, food represents love. There are several scenes in "Good Evening, Midnight" from *Batman Black and White* #3 that involve food as a symbol of love: the opening scene, the flashback to Bruce's birthday party, and the closing scene, in which Alfred removes the cake from the fridge and leaves it on the kitchen table for Bruce to discover. In that final gesture, Alfred is able to communicate to Bruce what is the unstated bond that holds them together: the love of a father for his adopted son.

Another thing I do at this point is begin to gather a file of photographs that relate to the assignment. The file will contain anything I feel is interesting or appropriate to the story. It may include location shots, character shots, pictures of angles or lighting, and anything I can use or for inspiration. I find this part of the process particularly enjoyable because it allows me to take a non-intellectual approach. I trust my instinct and give myself over to it. Invariably, a theme of some kind will emerge which leads to new and unexpected directions.

My personal commitment to individual assignments varies depending on the story. If I am pencilling and inking a story, I will spend more time on the preparatory stage. Pencilling requires more preparation than inking. If the penciller hasn't done the prep and reference work, it's impossible to accomplish that at any other point.

Often I will photograph locales and/or models to add to the already accumulated reference. I'm lucky to have access to the variety of locales that New York has to offer. I love getting on my bike with a camera to scout locations for both interior and exterior shots. Sometimes I take the pictures before I lay out any pages, and sometimes I take them after I know what I want. I'll frequently take photographs of friends in poses to help me with the drawings and have often jumped in front of a Polaroid myself. Digital cameras are great for this kind of work. Manipulated digital images are at the embryonic stages in the comic book medium, but they will come in greater numbers as the technology improves.

Beyond the value of using photos as reference points, this particular stage gets you out of the studio for a few days. It gives the comic book part of your brain a chance to rest. I always find something new or unique that inspires me to go in an unexpected path. It's also really fun!

In addition to pictures and themes and such, I also have a personal artistic goal for each story I draw. It may be a new interest or something I have been working on for a while and can be anything

from using blacks more effectively or working on improving my faces to focusing on architecture or trying a new page design. Honestly, *what* the artist is thinking isn't all that important. The most important thing is that the artist is thinking of *something*.

Once the script is in my hands and I have an idea of what personal themes I'd like to explore, I begin drawing. I sketch out the measurements of the comic page or lay the tracing paper on top of the board itself. A lot of artists start out with *thumbnails* (small layouts, about four to one side of an 8 1/2 x 11-inch piece of paper), but I like to work full-size because it gives me a better feel for the page. Whether or not to do thumbnails is really a question of comfort and preference.

At this point, my only concern is the relationships of panels to each other and to the shapes within those panels. I try to keep the thumbnail layouts as rough as possible so that the final drawing on the board will be fresh. Sometimes artists draw too much detail at this stage and as a result, their work looks stale and stiff. At this point, my drawings are just shapes and blocks of space where I try to create interesting compositions. If I think what I've done works, I go on to the next step. Personally, I tend to reject the first attempt at the layout. I have learned from experience that my second try is usually far superior to the first, so as a matter of process, I keep the first version, but always try another way. I choose whichever I like the best and go to the next step.

I "ink" the pencilled layouts roughly, using very broad-tipped markers at this stage. I want to keep the work rough, without details, in order to preserve the energy for when I pencil on the board.

A good way to tell if your layouts work, no matter what size they are, is to squint at the work. If the black-and-white shapes are clear and you can still tell what's going on in the story, you have a successful page. Remember that the goal is always clear and understandable storytelling.

I finish laying out an entire scene before I start pencilling on the board. I find this necessary so that I can judge whether or not these pages form a cohesive whole. I used to lay out and pencil one page at a time, but something would invariably come up in the following pages that would force me to redo the first page. This is a much safer and more prudent approach.

Once I've decided that I have a scene that works, I go to my lightbox. I place the "inked" layout on the lightbox with the ruled page on top of it, turn on the lightbox, and start drawing on the board.

One of the benefits of working this way is that the artist can move the layout around a bit to improve the design. A lot of adjustment goes on at this point. I can crop and edit any panel to make it work better if I so choose. I think the artistic process should allow the artist as much latitude as possible to incorporate changes into the drawing.

My pencilling approach is greatly affected by who is going to do the inks. If I am inking the work myself, I try to stay rough in my drawing so that my inks have something to add instead of just tracing my pencilled lines. If someone else is going to ink the pencils, I will make my drawings as tight as possible so that the inker has as little to do as possible. My goal is to keep as much control over the work I can to ensure that it reflects my own artistic sensibilities.

At this point it's worthwhile to mention the difference between Marvel and DC Comics in their approaches to scripting or plotting. Marvel almost never has a finished script to work from. The story is often a page or two of a plot that the artist breaks down into pages and panels. I prefer that method because it creates more of an opportunity for the storyteller to tell the story in his or her own way.

At DC Comics, the artist almost always works from a finished script that includes the dialogue and pages broken down into individual panels. Often the writer will give descriptions and directions on how to shoot or construct a particular scene. Because all the copy and dialogue are supplied, the artist can incorporate that information into his or her design and layout by leaving sufficient space for

them. This avoids the crowded-panel look, where sometimes the balloon goes over someone's face or hides other pertinent information.

It's critical too, to mention the importance of deadlines. I think that, above all else, editors and comic companies treasure timeliness. I cannot emphasize this enough. When I was starting out in this business, I knew I wasn't very good, but I tried to make up for it by being 100 percent reliable. Editors *really* appreciate this. I've had the experience of being in an editor's office while he or she tries to locate an artist who is either missing in action or just not answering the phone. Some artists take a job and disappear for months. This is not the most effective way to build a career. Once an artist develops a particular reputation, it is impossible to shake.

After a sequence of pages are pencilled, I hand them in to the editor. In the same way that there are two approaches to writing a story—the Marvel way and the DC Comics way—there are also two ways to letter the boards.

At DC, the editor sends the boards out to be lettered on the artboard itself. After they are lettered (which usually takes a few days), they go to the inker. I try to keep the process in a constant state of flow so that there is the least amount of time wasted. While the first batch of pages is being lettered, I pencil another scene. By the time the lettered pages are returned to ink, there's another grouping of pages in the hands of the editor, and the cycle begins all over again.

At Marvel, the pencilled pages are handed unlettered to the inker. This means that the inker rules the panel borders and then inks the pages. While the inker is working on the pages, the lettering is being done on a computer using copies of the finished pencils as a guide. After the inks are finished, they are scanned into the computer and the lettering is applied. The film of the lettered pages is sent to the printer, and the book is printed from the film. This means that the original artwork is returned to the penciller and inker without any words, balloons, or captions on it at all.

Once the pages are handed in to your editor, it generally means that the pencilling and inking are done. This is true except in the instances where a panel needs to be redrawn or some other art problem arises. Depending on the size of the problem, the artist would be well advised to follow up and offer to do any patchwork that is necessary. The in-house art corrections can be erratic, ranging from very good to unacceptable. All these things depend on time and proximity, but an artist needs to keep track of the project even after it leaves his or her hands.

Being involved in the book you are pencilling is a delicate situation for both the penciller and the editor. There was a time when the editor was in complete and total control of the project. No one had more input into the series than the editor. Today, the situation has changed. Although this is not true in all cases—there are certainly still strong editors in the business today—some editors have relinquished a certain amount of power to the freelancers.

I'm sure that this was done to develop more of a collaborative atmosphere among the team working on the project, but somewhere along the line, that relationship has become distorted to the point where the writer or the penciller is in charge of the book. It's important for everyone to realize that, ultimately, an individual commercial comic is an effort made by many people. I've observed over the years that mainstream comics work best as a team effort. This is not to say that a comic will automatically be a failure if only one person does everything or if a single artist or writer controls the book. Independent, small-publisher comics can benefit from that kind of approach. It has been my experience, though, that teamwork produces the best results in monthly, mainstream comic books.

# FOURTEEN
# BREAKING IN

Breaking into the comics industry can be a frustrating and haphazard process. I've seen people carry around a portfolio for years with no success and I've seen artists get discovered at a convention overnight. It took me two to three years of persistent pushing before I got my first real art assignment. I had dropped out of college and was living in Connecticut with my parents, working at a fast food chain. Any money I made went right into art supplies and train fare to New York. I would try to hit DC and Marvel at least once a week each. Along with a very steady stream of rejections, both DC and Marvel were nice enough to supply me with copies of pencilled artwork that I would ink on vellum in between the visits for practice. Sometimes I think that it was inking all those copies that gave me the hands-on experience I needed. I'd go home, ink for two days, and get right back on the train with new pages, a few sandwiches, and a bit of hope. It was a perpetual-motion machine. Between you and me, I think I just wore them down!

As you try to break into the comic book industry, you should focus on two areas: your *portfolio* and your *personality*.

Your portfolio is essential. It is the only way a professional can evaluate your talent. It is the only representation of your work that the editor or artist sees, so you should take special care in developing a good one.

Here's what a portfolio should contain:

**1. The original pages or copies of your pencils.** Ideally, you should have about six to twelve pages of artwork. Anything more than that is too much. It's important to trim your presentation down to a manageable length. Show what you can do and don't repeat yourself. It should be easy to assess the extent or limit of your abilities based on your twelve pages of art.

This means that the pages should contain at least two different scenes of at least three pages each. Usually three pages of a scene are enough to judge an artist's storytelling and drawing abilities. It's a good idea to draw sequences that contrast with each other. One can be an action scene; the other, a quieter scene. The point is to show that you can handle a variety of situations and still tell the story well. The more convincingly you handle a sequence, the better your chances are of getting an assignment.

If you have six to nine storytelling pages, the handful of pages remaining should be devoted to showcasing your drawing. A few pin-up pages or covers would round off the portfolio nicely. Including them also shows the editor that you can draw pretty pictures as well as tell a sequential story. Keep in mind that the pin-up pages are in addition to—not instead of—the storytelling pages. Editors need to see how well you can tell a story and that must be the focus of your presentation.

**2. Reduced copies of your work.** The entire contents of your portfolio should be reduced and copied onto legal-size paper. Staple the copied pages together to form a little packet. On the first page of your copied artwork, put your name, address, and telephone number. If you have a business card (a great idea), attach it to the packet. You will hand these pages to the professional who has viewed your portfolio. It doesn't matter who it is, give everyone who looks at your work a copy! Some may get thrown away, but a certain number will make it through. This is a critical maneuver in the process. No one can remember your portfolio after a convention, because they have looked at so many people's work. It is always best to have reduced copies so that the professionals can take your work with them and pass it around to their colleagues.

You should also give some thought to your presentation. Keep in mind that you are a storyteller. Try to arrange your pages in an attractive and compelling way—create a story with them! Start with a pin-up, introduce a sequence of pages, then insert another pin-up or two before the next sequence. Think of a way to make the portfolio interesting and memorable from a purely visual point of view. Whoever is looking at your work will be able to tell if care has been given to the presentation. Remember that all of your portfolio reflects back on you.

Keep your portfolio as specific as possible. If you want to be a penciller, do not include inked or colored pages. You may be multitalented, but it's important to keep your portfolio simple and direct. If you feel that you want to be a penciller, inker, and colorist, you may certainly present a portfolio that showcases all of those skills. I have to tell you, though, I have seen that work against almost everyone who has done it. First of all, it confuses the editor or art director. They won't know what you want to do and, as a result, will not know how to help you. The other flaw in this plan is that you cannot be equally adept in all of these areas. It's just impossible at this point in your career. You may be great at inking, but your pencilling might be poor. Or the opposite may be true. It's very difficult to be equally proficient in all areas of comic art, especially at the beginning of your career, and one weak or underdeveloped area will bring your whole portfolio down. Focus on your strength, break into the business sooner, and then expand your talent and range once you are on the inside. In the same way that storytelling is best when it is specific, so is a portfolio.

*Do not,* under any circumstances, ever present unfinished pages. This is the kiss of death as far as any critique is concerned. It usually means you will be dismissed very quickly. No one wants to hire an artist who's good at drawing half a page. Whether your goal is to be a penciller, an inker, or a colorist, finish your portfolio pages completely.

One thing you might try to avoid is writing your own story for the pages you submit. The only exception is if you are intent on creating your own character or even self-publishing. If you want to work at an established company you should probably not show work you have written for one simple reason: artists write to their strengths. If you hate drawing buildings, odds are your story will not take place in a city. If you hate drawing fight scenes, you will write a story that mostly involves talking. Editors want to see how you handle not only the things you like to draw, but also the stuff you might hate. There will definitely be times in your career when you will take on an assignment that contains a sequence or a location for which you have no affinity. Unless you write your own stories, this happens quite a bit. And that's the point: You need to show that you can handle any curveball that the story contains. If you limit yourself to stories that only take place in the forest, there will not be a great demand for your work. Try to get a hold of a script somehow—I know there are a few floating around in fandom. You may even find one or two at a convention. That way, you can create a few pages of artwork using a real script.

# Conventions

The best place to showcase your work is at a convention. There are two main reasons that pros attend them:

**1.** To have fun, mix with other pros, and get adored by their fans.

**2.** To find new talent. No company can survive for very long without an infusion of new people with new ideas. Conventions are a great source of that.

An artist will probably give you a better critique than an editor, but an editor can give you a job. Take that into consideration when you approach people. Make sure you know who people are before you speak to them. If you want to get some inside tips on what you are doing right or wrong, talk to an artist. If you want to find out when you might be ready for work, talk to an editor. It's similar to the approach you take when you work at telling a story. Be specific and aware of what your goals are.

Use both the artists and the editors to get as much feedback as possible. Conventions are extremely useful and practical because of the high concentration of professionals who are willing to review portfolios and give advice. The comic book is a unique art form. There's nothing more useful than talking to someone on the inside of the industry.

Another advantage to the convention is the opportunity to network with other young artists who are trying to break into the industry. Whether it's to hunt down a script or get information about new projects or companies, you should try to meet as many non-professionals as you can. Finding some support from people who are going through the same thing as you are can be very beneficial. Most civilians, sometimes including your family, don't take comics seriously. And that's okay. As long as you connect with other people in the same situation, you can get the support and friendship you need to see this adventure through.

Don't be discouraged if you don't get hired right away. Take the long-term approach. Breaking in is not about getting the chance to do your favorite character tomorrow. It's about laying the groundwork for a lifetime of employment. Be patient. You are building a career, and it will take time.

This brings us to the second important factor in the process of breaking in: your personality. You are probably wondering what your personality has to do with your portfolio or career. I will tell you that it has *everything* to do with them. Your personality is a part of everything you do, and is certainly involved in your presentation, your work habits, your relationship with your editor, and your relationship with yourself. From my own experience and the experience of observing many students through the years, I know it is a surprisingly strong determining factor in your career. I have seen many very talented artists, who had more than the necessary talent to succeed, fail because of their personalities. And I have seen an equal number of students, some of whom I dismissed as having no chance, succeed by the sheer force of their personalities. It proves to me without a doubt that being a talented artist is not the only requirement for having a successful career.

When you have the opportunity to have your portfolio critiqued, you will respond in ways that can either hurt or help you. It can be hard to listen to criticism of your work. Everyone has a different approach to evaluating your pages. Some may gently provide advice; others may offer harsh criticism. Their approach often has more to do with their own personality than with your work. You should always take the criticism to heart, but you should also realize that the manner in which it's given is out of your control. It's best to get a lot of feedback, add it all together, and try to average it out. What was the one suggestion everyone made? Focus on that problem and work to correct it.

Even though you have no control over how or what the critic says, you do have control over how you respond. No matter what is being said, *do not,* under any circumstances, make excuses for your work. Do not defend it, do not explain it, do not rationalize it (unless you are asked). The best response you can possibly make is to ask how you can make the work better. No one wants to hear excuses. The pages in your portfolio represent your work. Everything is said within them. There's no need to say anything else.

Excuses and explanations also indicate that you are not listening. If you are thinking of a defense, than you are more interested in how you appear than how to improve your work. You are not there to argue your approach or your work. You are there, however, to pick up some advice. Don't focus on defending your ego. If you want to get something out of a critique, develop a thicker skin and focus on the work. I know this is difficult, and it takes time, but it's important for your career. The more you practice, the easier it becomes to control those all-too-human impulses.

Finally, try not to present an attitude. Everyone is vulnerable during a critique or job interview. Believing in yourself is necessary to see this process through. Believing that you are the best artist alive and everyone in the business stinks and you don't understand how come you are so good and still not working is *not* the best approach for someone who needs to learn. I'll tell you that almost everyone I know has gone through the experience of projecting an inappropriate attitude during a critique. I did, too, and because of that attitude, I lost out on several opportunities for work early on in my career—which made my attitude even worse. It was when I started to do some work on myself that comics work became more plentiful and, frankly, I became a happier person.

When I look back at some of the early work that I did, I see how uninformed and ineffective it was. I think I had a few areas of interest (like lighting, texture, and an obsession with creating depth) that distracted from my fundamental inadequacies. Those good qualities and abilities saw me through long enough to learn something. But I wasn't going to let anything stop me from becoming a better artist. I was fiercely determined to break in and stay in this business; it was what I wanted more than anything else. The ability to stay determined and the desire to constantly improve saved me and saw me through the rough spots. I know that if you have the ability to work on your craft, to work on yourself, to want this more than anything in your life, then you will succeed. I can promise you that!

"Good Evening, Midnight," from *Batman Black and White* #3, was one of the rare projects that seemed to achieve much of what I set out to accomplish. When Mark Chiarello, the editor of the series, asked me to contribute a story, there were several reasons why the assignment was so attractive to me. First and foremost was the lack of color. To do black-and-white art has always been a great interest of mine. I feel that many of the jobs I have done have been destroyed by bad color choices. All the theories we've spoken about in this book must also apply to the coloring. Effective use of depth, perspective, primary and secondary shapes, time of day, movement, lighting, contrast, and more are all goals of mine in every story, and they are often undermined and negated by a colorist who is not sympathetic to my thinking. The opportunity to do my own coloring or the chance to do a black-and-white story ensures the follow-through that is necessary to see an artistic vision realized.

Another reason the project was so appealing was the challenge of doing a story with some meaning within the constraint of a relatively short format. I've always been a great fan of Will Eisner's *The Spirit.* His ability to create a complex and meaty story within a few pages still amazes me. By contrast, some recent short stories in comics had disappointed me. They seemed not to be stories, but rather plotless vignettes. As a fan, this would tick me off quite a bit. I often felt cheated by the quality of those stories and vowed to avoid that as much as I could.

The final reason I jumped at the chance to be involved with this project was the opportunity to try to say something different about the Batman cast—something that might not have been extensively explored in the past. I didn't have a clue at the time what it might be, but therein lay the challenge.

At some point, the notion of exploring the relationship between Alfred and Bruce Wayne occurred to me. I can't recall why, where, or how this happened, but story ideas usually sneak up on me when I'm not thinking about work. Sometimes an image may pop out of nowhere. I might be reading or watching a movie and I'll notice my response to a scene. I then try to bring what is in my subconscious to the conscious level and examine what triggered the reaction. Interpersonal relationships of all kinds fascinate me, particularly the parent/child dynamic. I knew at some point that the story would be about the unspoken love between Alfred and Bruce.

Now that I had a pretty good idea of where the story was going, what I needed was a subplot to contrast with the main theme. I'm a big fan of cutting away from scenes and knew that the Alfred/Bruce relationship could not sustain the story by itself. I also knew that it would probably be best to cut to some kind of crisis or action because the story of Alfred and Bruce was going to be presented in a very understated way. The problem was space. How much of an action or crisis could I set up within the space limitations?

It was at this point that I connected "Dear Prudence," written by John Lennon, to my story. The song is a wonderful example of the use of a repetitive riff that overlays instrumentation over and over again to form a more compelling structure until it reaches its climax, at which point the layers of sound drop out to reveal the original riff introduced at the beginning of the song. This simple beginning that

builds to a climax to reveal the simple beginning again was a great inspiration to me.

I constructed my story in a similar way. A simple beginning where the Batmobile leaves the Wayne Mansion; a more complex middle with three stories intersecting (young Bruce's birthday party, present-day danger with a school bus is held hostage, and Alfred's relationship with Bruce); and the ending, which returns to the simple beginning as the Batmobile returns to the mansion.

## Page 1

Page 1 opens with an establishing shot of Gotham City with the Bat-Signal above it. The signal in panel 1 juxtaposed with the Batmobile in panel 2 immediately relays information in a very quick and economical way. It's what I refer to as a "call-and-response" structure. It also falls under the theory in storytelling (and physics) that for every action there is a reaction.

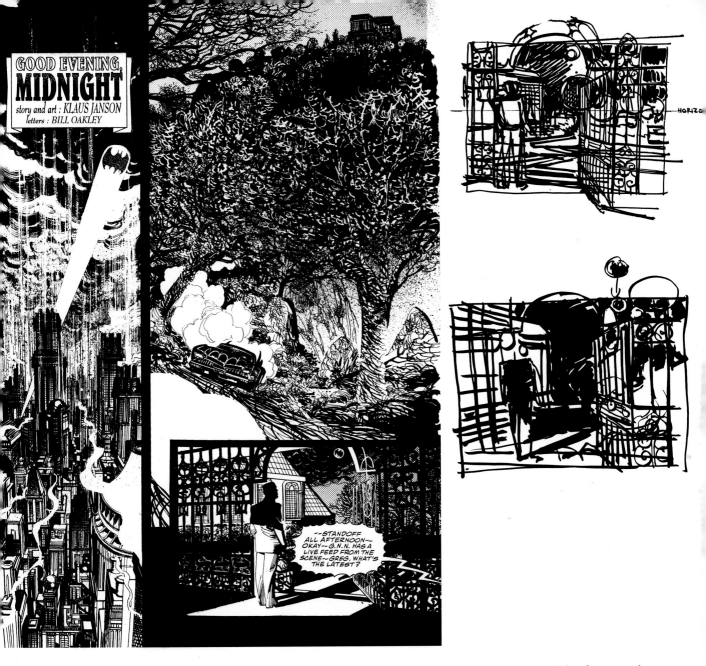

After the Batmobile exits Wayne Manor, I originally had two panels on page 1 and the first panel on page 2 showing Alfred looking out the window. I liked the idea of keeping Alfred stationary, with the camera doing all the movement, but in the end, I rejected it. I realized that I was violating one of my personal rules about storytelling: show an action clearly once and move on. Unless there is a deliberate use of repetition, which I do sometimes like to employ, watching Alfred looking out the window for three panels is not very economical storytelling.

Often when I both pencil and ink a story, I will make changes between the two stages. I found a photograph of a wonderful gate that inspired me to use it in this sequence. I thought that if we could see what Alfred is actually looking at instead of leaving it ambiguous (as it was in the original pencils), the shot would be more interesting. I positioned Alfred outside the mansion with the Bat-Signal in the panel.

Page 2 was an interesting page to figure out from a storytelling point of view. There was one important piece of information that I wanted to get across without having to say it: that Bruce was suddenly called away from dinner by the Bat-Signal and the crisis it represented. The second panel of page 2 shows Alfred picking up a dinner plate with food still on it. The idea was to convey that Bruce's meal had been left unfinished, so in an attempt to communicate that point, I decided to hide Alfred's face until panel 5 so that the reader would be focused on the food. Whether this was strong enough to succeed I don't know, but I liked the idea of it very much.

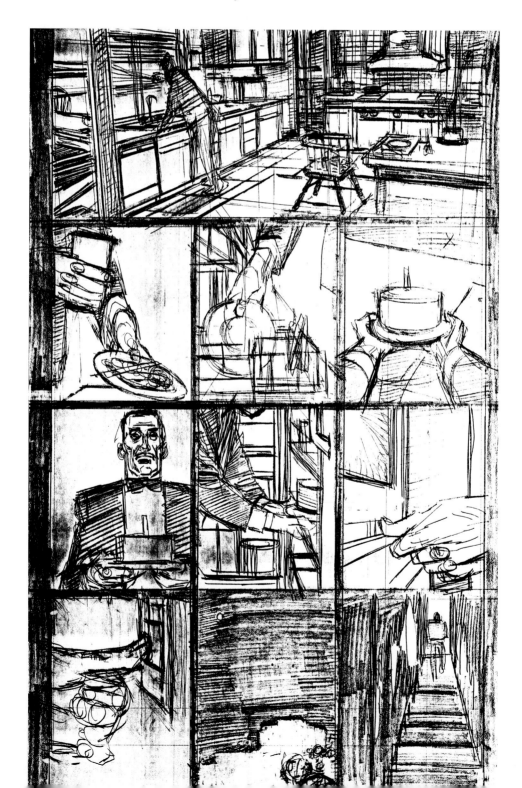

One of the consistent characteristics of my work is the use of weather. From living in the American Northeast, I have become very aware of the changing seasons, and I really appreciate them. Since one of my goals is to squeeze as much as I can out of every opportunity, I almost always include specific weather on my pages. If you look at page 1, you will notice that it is drizzling over Gotham but not over Wayne Manor. I wanted to communicate in a very subtle way that the distance between the two is substantial, that Alfred could, in real time, actually shut down the mansion and have time for a flashback before Batman arrived at the crime scene. In any case, if you look at the interpretations of weather throughout the story, you will notice that each scene has its own specific climate. The bridge scene is wet and rainy, the flashback is cold and snowy, and the mansion is dry and calm.

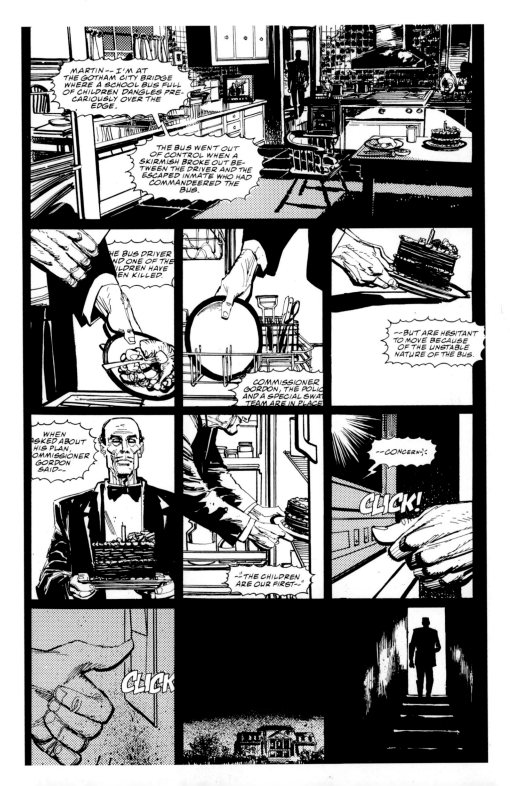

I was also very interested in showing some of Alfred's personal life. I couldn't remember any story in which Alfred's room is shown. I mean, where does this guy actually *live?* What does he do when he tries to relax? So on page 3, I tried to show a bit of that by introducing his room and his cat. Since Batman and Bruce are gone for extended periods of time, I knew that Alfred had to have company of some sort, so the cat made a lot of sense to me. The room was extensively researched and designed to reflect Alfred's fastidious nature. The one joke I knew no one would think about is how Alfred relaxes. He enters his room and takes off his jacket, leaving on his shirt, suspenders, pants, and shoes, but putting on a sweater. Even though this is in keeping with his character, it still cracks me up.

The shots and angles on page 3 were chosen for a variety of reasons. The entire page is designed with the horizontal and vertical structure in mind. The only panel that is an exception is the next-to-last one, a subjective shot in which the viewer sees what Alfred sees. You'll notice that the box is at the same angle as Alfred's left arm and the letter is at a definite angle in contrast to both the borders and the arm and box. It was a compositional attempt to make that panel stand out a bit more. It was the most important panel on the page, and it needed something to draw some attention to it. If you look at the page as a whole, I think you'll see that it does stand out.

The middle tier is a sequence designed to let the reader focus on Alfred's environment while at the same time following him around a bit. This technique of breaking one scene into various panels forces the reader to stay a bit longer on that scene.

In the last panel, I originally had Alfred's eyes showing above the letter (see the rough sketches on page 130). However, as soon as there is a face in the panel, the reader quickly focuses on it, and I wanted to draw attention to the letter only. That, coupled with the hope of smoothly segueing into the next page, inspired me to raise the letter to hide his eyes. The shot was important enough to warrant several attempts to get it right. In retrospect, I think I should have shown even less of Alfred's head.

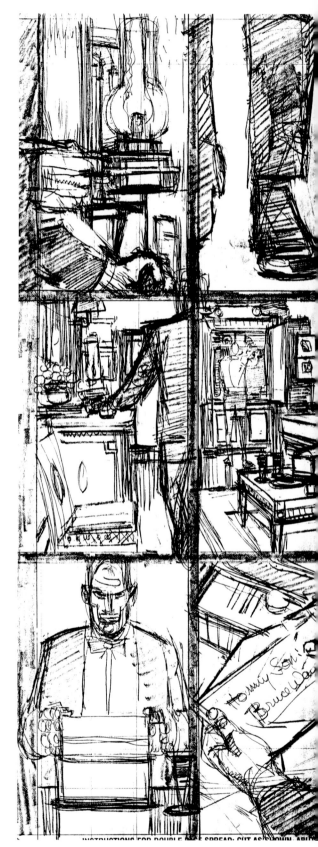

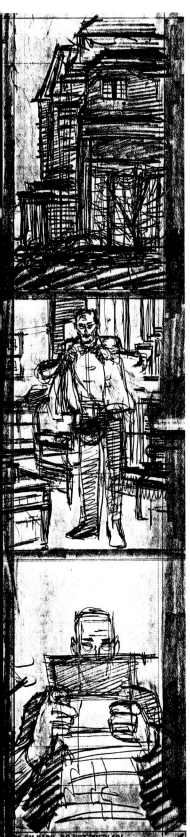

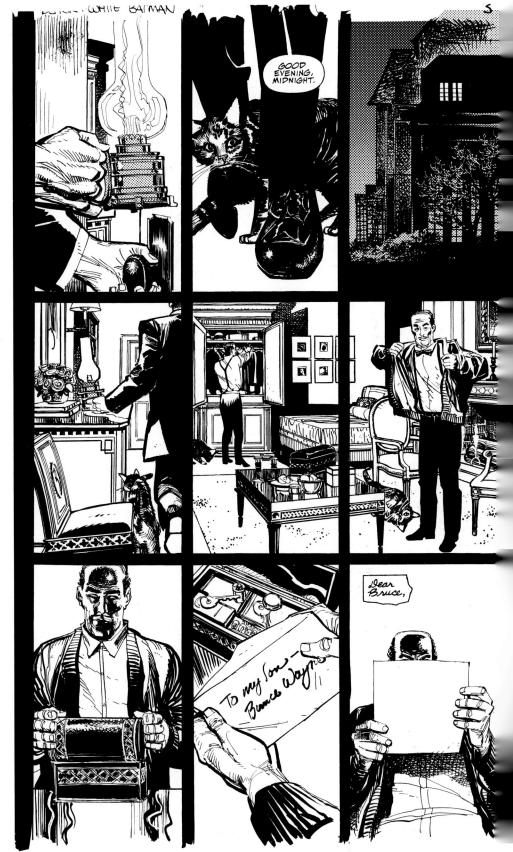

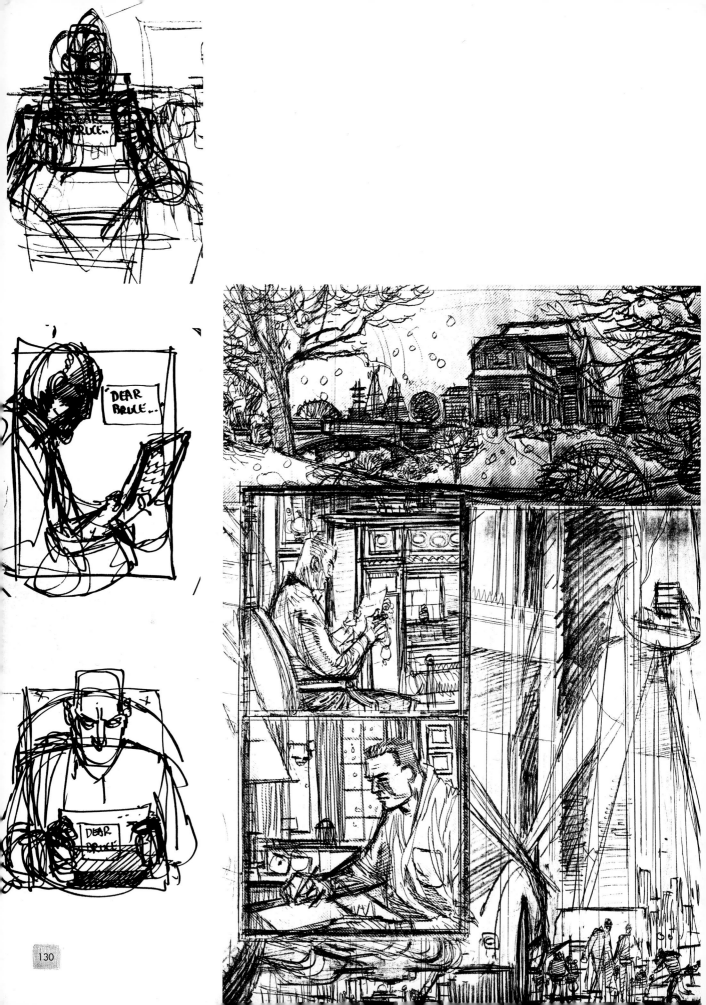

On page 4, the audience sees the three plot threads on one page for the first time. The first panel is a flashback, the second panel is present time with Alfred, and the last panel is present time with Batman. Although they all occur on the same page, I tried to make them look different enough to give each an individual time, place, and identity.

Music has consistently been a major influence on how I approach my work. I think of each scene as a song and the whole story as a complete CD. One of the things I have learned from that structure is to give each scene a unique "sound" of its own. I've found that this works with varying degrees of success, but the thought behind it is still valid. In this case, I gave each individual scene a unique texture that was identifiable with that particular scene only.

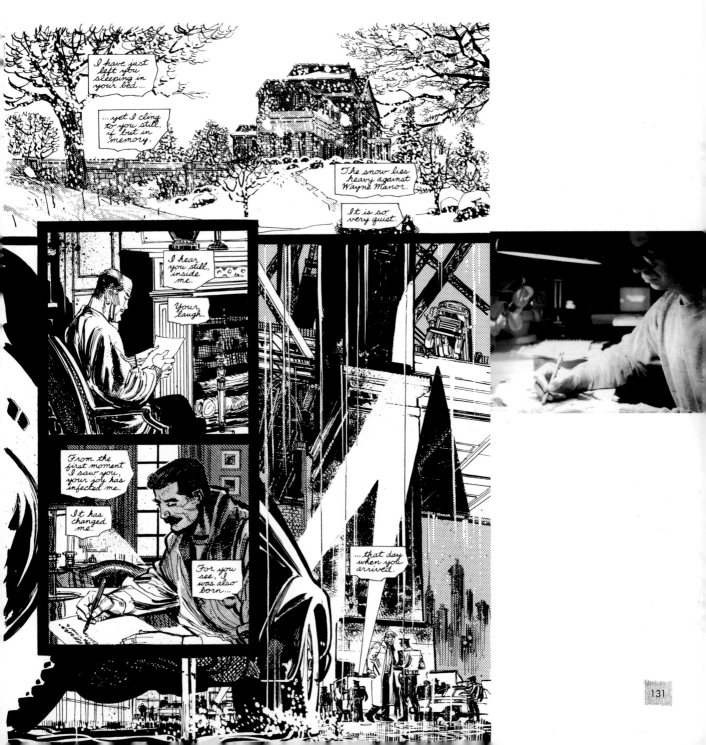

# Page 5

The first panel on page 5 gave me a bit of trouble. I went through two other versions of the panel until I settled on the printed one. I wanted the panel's focus to be divided equally between baby Bruce and his dad, Thomas. The unused versions weren't able to do that as well as I would have liked. I finally came up with a shot that was less "arty" and more direct, and chose that one. Working diligently on storytelling doesn't mean you will wind up with a more complex panel. It often leads to the most clear and unobtrusive choice.

In this panel I composed the two focal points so that the reader has to go back and forth between the two. The vertical black that Thomas Wayne touches with his left hand serves as a framing device for Bruce. In a way, it gives each of the two characters his own panel. The diagonal between the two characters allows the reader's eye to flow from the baby to his dad and back again. Even though Thomas Wayne has the majority of the panel, the compositional elements on the baby's side are very compelling. Note the relationship between the baby's bassinet and the white screen behind him. It draws the eye of the reader into the panel and down to the baby, and balances some of the "weight" that the Thomas Wayne shape has.

I was very happy to be able to continue the identification of the scenes with individual weather even though this scene took place indoors. I had always wanted to draw a coat with snow on it and got a kick out of doing it here. The coat's appearance also

communicates something about time—Thomas was in such a hurry to get to the hospital that he raced through the building before the snow had time to melt.

I was pretty happy with the composition of the page. The first panel has the large shape on the right. The second panel has it on the left. The third panel has it on the right again. The line of the bus points to the small figures of Batman and Gordon. The eye of the viewer moves in a constant back-and-forth motion until it ends on the insert panel. There is a lot of contrast between small and large shapes, which I think makes for an interesting page.

My favorite sequence on page 6 is the Alfred scene toward the bottom. I enjoyed constructing the page and story in a way that would tease the audience. At one of the most critical points, as Batman appears to be in danger as he swings/climbs up the bridge, we cut away. The scene served no other purpose than to build tension and prolong the anxiety of the sequence. This particular construction is very influenced by both music and film. The Alfred scene serves as a moment of respite before we get back into the rest of the story.

 To be honest, I think that page 6 is probably the weakest page of the story. I get the feeling that the actions are not as clear as I would like in panels 2, 3, and 4. If I could do it over, I would choose different images and present them in a different way. I like the first panel, but not as it is juxtaposed with the following three. That birthday scene, by the way, was originally set during Christmas until I realized it really should be a birthday party so that the past tied up more directly with Bruce's current birthday. It was part of the circular motif that I was exploring, inspired by "Dear Prudence." Scenes and images refer back to themselves and echo throughout the story.

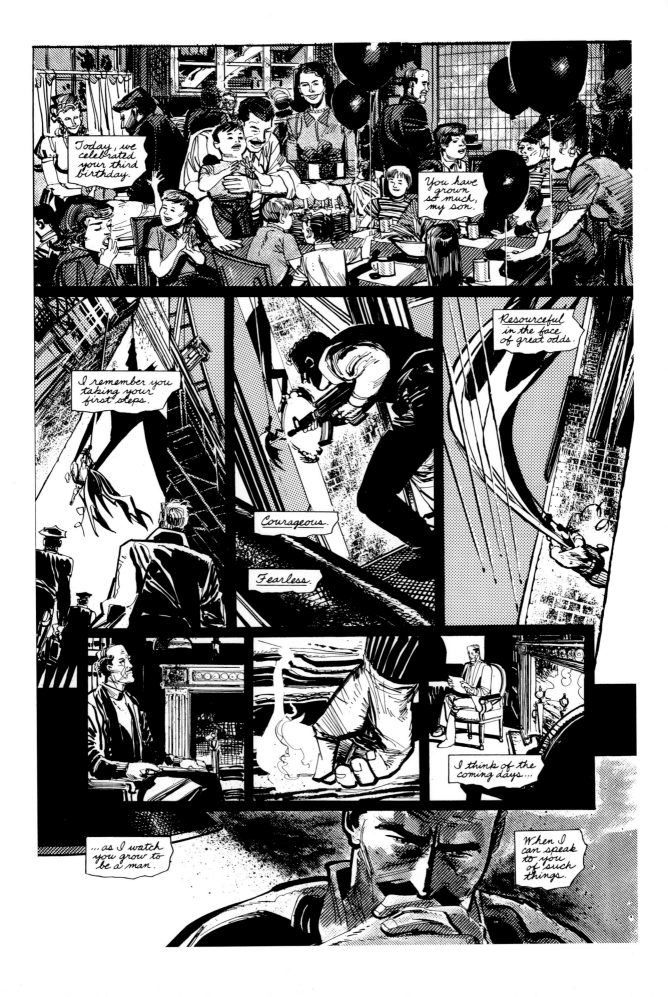

On page 7 is the only panel in the story that is neither vertical nor horizontal: panel 3. It depicts a very dramatic moment that leads into a large panel showing Batman having achieved his goal. Panel 3 was meant not only to visually lead into the next panel, but also to represent the moment of the least stability. My editor, Mark Chiarello, constantly reminds me of how much he hates the kid's head positioned in front of the panel the way it is. In retrospect, I think he's right. It is an unnecessary distraction, although I would never admit that to him!

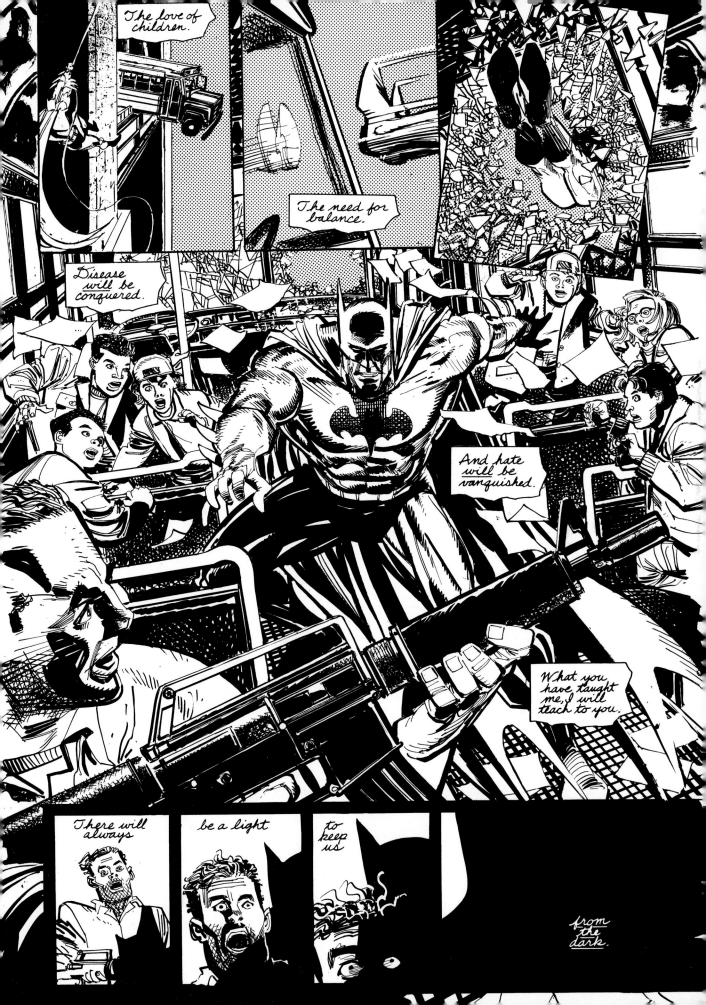

One of the things that surprised me when I opened my files on this story was how extensive the photo reference was. It looked like I had shot pictures for almost every panel. I remember spending a Sunday morning taking pictures of the 59th Street Bridge here in New York, and another day taking pictures of a parked school bus in my neighborhood, but apparently I posed for pictures and snapped photos with my timer and Polaroid for most of the characters. The first panel on page 8 was based on a photo of me in my studio. I know the third panel was based on the face of Senator Bob Dole, so you truly never can tell what the source of an idea or reference will be.

The fourth panel required some decision-making. I was really torn between two choices: Alfred keeps the letter or he destroys it. I thought for the sake of drama that it would be more impressive to burn it, and I think I was right. But I remember standing in the halls of DC and talking to editor Archie Goodwin about it. He thought that it made more sense for the character and the story if Alfred saves the letter. If Alfred truly was a father to Bruce and loved him like a son, he would do what was best for Bruce. It's a lesson I have learned many times in this industry: do what's right for the story and the characters. You may have a great idea for a scene or a character but it is not worth doing at the expense of the story's integrity.

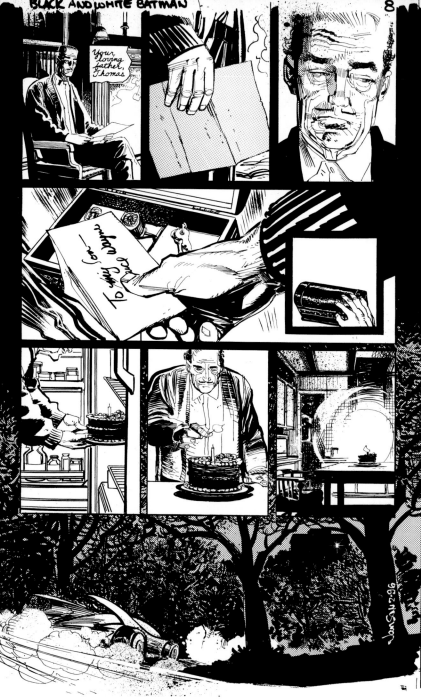

By the time Alfred puts the letter back, he is reminded of how much Thomas Wayne loved his only son. Whatever pique he might have felt at Bruce's sudden departure from the dinner table is now replaced by the love he has for this child he raised as if he were his own. He goes downstairs and pulls the birthday cake out of the fridge and puts it on the table. In a small gesture, the cake serves as a reminder to Bruce that someone cares and watches over him.

The goal of this chapter has been to reveal what I was thinking when I wrote and drew this one particular story. It is not meant to encourage young artists to duplicate the specific themes that I embraced. It is, however, intended to show that comic books and storytelling can have more depth and complexity than the average reader might see at first glance. Storytelling is limited only by the imagination and courage of the storyteller. I'm convinced that comics can go anywhere and do anything as long as the working artists and writers believe in that. The combination of some simple rules encouraging storytelling clarity and the dreams of artists hungry for expression is unbeatable. I hope that this book provides some inspiration to all who love this wonderful craft.

# AFTERWORD

If you are reading these words, you are probably finished reading this book, so congratulations! Soon after I started teaching, I began to notice that many students had the same problems. This book is an attempt to provide some insights to the issues those young artists were facing and to offer a few solutions. No one book could ever claim to teach the "only" way to create comics, so I chose to offer a basic and fundamental analysis of the powers and problems of visual storytelling.

It's important to realize that your own philosophies about art will develop as you mature as an artist. Each new story you tackle will present unique challenges and opportunities to expand your abilities. My own outlook on the craft of creating comics has evolved over the years, and my goal is to continue to update this book in some form as often as I can. I know that I will revisit this book often. I hope that you will, too.

Klaus Janson
New York
November 2001

# INDEX